# The Business Of Professional Art

A series of 30 columns from

Belle Armoire
ART TO WEAR

By Sarajane Helm

# The Business Of Professional Art

Copyright ©2007 Sarajane Helm

**All articles were originally published as**
*The Business Of Professional Art*
**in Belle Armoire® Magazine 2003—2008.**

First published and printed as a paperback in
the United States of America in 2007
by PolyMarket Press

ISBN 978-0-9800312-1-8

POLYMARKET PRESS

For more information about our books
and the authors and artists who create them,
please visit our web site:

**PolyMarketPress.com**

*With heartfelt thanks to all my dears
and to all the enablers of creativity everywhere…
keep it going!
To Kate Hagerty and Deb Craven at FRCC
who solved every technical question.
And especially to my sister Kelly, who is my favorite editor
as well as an excellent writer herself.*

III

# Table Of Contents

# Table Of Contents

# Knowing Yourself

Frank Lloyd Wright once stated that salesmanship was the art form of the new age. A man of great perception, he was his own greatest promoter, and seemed to know exactly how to go about being an artist in that media as well as in stone and glass, textiles, metal and wood. Not all of us are as innately full of the belief of the value in our own work but that is indeed where salesmanship starts. The first step, no matter your choice of venue, is to believe in the worth of your creations, and to work to make the best of your abilities and available materials.

As artists, we have all looked upon the goods in the marketplace at one time or another and thought "I could do better than that". For every masterpiece, there are hundreds of thousands of pieces that are of lesser quality, and there are people who will gladly buy either—the trick in marketing is to get items to be seen by their potential new owners. Merely placing them on a blanket in front of a crowd is not enough, and in today's world of licenses and laws, it may even get you in a great deal of trouble, depending on your location, and how often you try it! The life of the vagabond artist, taking that blanket and those goods here and there, or selling from the trunk of the car, is one that has survived from ancient times. And yet, with its traditional risks of fines, impoundment, and even worse, most artists who wish to sell will quickly find the appeal of that sort of hit-and-run marketing fades quickly.

There are many ways to sell one's work. One of the easiest occurs when someone says "Oh, I just love your (hat, pin, necklace or whatever) and where can I get one?". Then you take it off and exchange it for cash on the spot. However, this is not something on which you can count to happen

daily. If you wish to be a Legitimate Business, then you must participate in all the ways required by your local laws. This includes things like a having a sales license, sometimes called a re-sale license, or sales tax ID, or by other terms. It includes selling from various forms of permanent or temporary locations that are zoned commercial, like Galleries, Boutiques, other stores, craft shows, art shows, and specific market conventions, as well as home parties, through the mail and the Internet. It includes keeping track of all sales or trades (barter) and paying all applicable sales taxes, fees, and commissions. In turn, all these legitimate expenses are recorded every year and declared on your Federal and State taxes. (I am speaking from experience in the United States and there are different laws in other countries—and laws change, so you need to check your local statutes. I am not a lawyer. I do try to keep up on changes in law that affect me as a small business person though because its in my best interests to stay informed. )

In return for compliance with the Rules, you are free to make a living without fear of violating laws and also receive benefits such as being able to purchase items needed in your business at wholesale. You may also pay no sales tax on items you purchase that will be resold (this includes your raw materials for your work, not just finished items). Conforming to the laws of business, and establishing a legitimate presence in the marketplace also presents YOU in a professional mode, as well as your work.

You become more legitimate in the eyes of your peers, and to your prospective clientele. This can translate into more opportunities for sales, as well as the ability to command a higher price for your work. It also has other benefits down the line including your place on the Social Security list, even the occasional income tax refund!

For more information on the legal aspects of business, check your local library. Not only are there many excellent books on the subject of small business, you can also find out where to contact your state's Department Of Revenue (or its equivalent). There are also many resources that are invaluable to a professional artist, including magazines such as Crafts Report, which list shows and sales venues throughout the United States, and which carry articles of great interest to those attempting the business of art. The libraries also have the Thomas Register of American Manufacturers, in which you can look up information on suppliers of all sorts. You can pay out money and go to seminars or classes to find the same facts--but with a little work, you can do that part yourself for free--and that is an important thing when starting out small. Do it yourself when you can, and farm it out later when you are in a position to do so, whatever the work. If you have done it yourself, you will know if the pros you hire are doing it well later on down the line!

Conforming to the local, state, and federal laws, and having a product in which you believe, is not enough to make you succeed in business, but it IS the place to start. You still need to get that product "out there" to where the buying customers are. There are many venues ranging from the blanket on the Village Green or yard sale on up to much pricier surrounds. These include Museum Galleries and the finest of stores, and when your work gets there, it needs to be properly presented in order to command notice in a world crowded with buying opportunities. Each kind of venue has its own marketing "slant" and its own customer niche. The crowd at the local fairgrounds is an entirely different market from that at a Rodeo Drive or New York glamour Boutique, even when some of the same people are shopping at both. Customer's expectations have a lot to do with marketing!

This is where knowing about your intended buyer is vital, so that you can pitch your product effectively. Brand new hand-tooled and dyed ostrich leather boots at a flea market or yard sale will perhaps fetch five dollars, whereas they may be priced a hundred times that or more at an upscale market.

So how do you identify your market, and how to successfully promote your product in each? As an artist who has sold many kinds of wearable art over the last quarter century, I have learned a lot about many types of venue, including:

### DIRECT SALES
- Flea markets, garage sales, and boot sales
- Craft shows, church bazaars, home parties
- Professional conventions
- Gift Marts
- Owner operated stores
- Trunk shows
- The Internet
- Barter for foods or services

### INDIRECT SALES
- Consignment to other stores or galleries
- Sales Reps
- Wholesale to other business
- Product placement
- Instructional outlets
- Designs only

There's a whole world of ways to promote your artwork , and we will be discussing the best ways to do so for each market—they vary considerably. May you find your niche and enjoy much success, both as an artist and as a businessperson!

# Name It; It's Yours!

One of the first things you'll need to know when getting started with the paperwork aspect of professional art is the "DBA" (Doing Business As) or name of your new "baby"! The name you choose will represent your business to the world and especially to your prospective customers. It's good to have a moniker that is memorable and easy to pronounce. It can have something to do with your own name, or your product line. (If you have several product lines, you can still promote them all under the DBA you choose). Using humor and sentiment in naming is often quite effective. I call my line of children's clothing "Cuddle Bunnies" and the adult clothing line "Freudian Slips". I use the DBA "Sarajane's" and it covers them all, including beads and other wearable art.

To see what names are in use by others, look in registries like Dunn and Bradstreet or The Thomas Register. This is the most comprehensive resource for finding companies and products manufactured in North America; it's a good source for finding suppliers as well. These books are available in the Reference Section of the local public library, or on the Internet.

Use Internet search engines to see if names you like are in use already by others—you may find that there are many "Originals by Ann" or "Handmade by Helen" now being sold out there. You can still legally use your name choice unless it has been registered as "Trademarked", but you may want to look further to find something more unique. Had I had married into the Butterworth family, I would not be able to use "Mrs. Butterworth" as my business name—but I might like "Butterworth Beads"!

Write it down on paper, and look at it over a period of days, also say the name out loud. Ask others to say it so you can hear how it sounds. Pretend you are answering the phone at corporate headquarters—how does it sound, repeated several times over? Request opinions on the name. Ask people you like and also ask a stranger or two. See what others recall when you ask them a week later. Do they remember the name, or something similar? Ask people what they think this company does, when they hear the name. Also be sure to look at the initials in a multiple-word name; see if your choice spells anything you'd rather it did not.

Regard the input of others, but ultimately go with the name that pleases you. You are the one that will be seeing and hearing it the most often. Once you decide upon the name, you will use it in thousands of ways to promote your efforts. It will be important in the representation of the actual product lines as well as the business entity itself. You'll use it on letterhead, business cards, catalogs, brochures, labels, forms, and signage of many kinds.

Doing business in the professional world requires certain legal details including registering for what is sometimes called a sales tax, resale or business license. You are to collect and pay sales tax on retail sales you make and to report retail and wholesale earnings to various city, state, and federal agencies. These things all vary quite a bit according to your location but a few hours of research and phone calls should allow you to find out what is needed for your business in your geographic area.

Look for your state's Department of Revenue in the phone book. Some forms of business have additional legal requirement. Quilts and quilted clothing, stuffed animals and dolls must use new stuffing or batting, and have a label

stating the fiber content. Clothing and toy items meant for children have additional requirements as well. Research what is required in your own media and place.

One major benefit of having a sales tax license is that I can buy supplies at wholesale instead of retail prices. Although certain minimums must be met the savings are substantial.

Also, items meant for resale do not require sales tax paid. Some venues only sell to professionals in the industry and require proof, which I have in the form of this license. Being a registered professional can have many long-term benefits. State and Federal Income Tax returns are part of the responsabilities that come with being professional, so train yourself from the start to save every receipt that has anything at all to do with your business. It all adds up at the end of the year to be valuable to your success. Although there is much information to track and paperwork to file, the results are very often worth it, and always educational.

# The Art Of Presentation

Once you have decided on a name for your business and registered it with your state Department of Revenue, you will be the owner/operator of A legitimate business, one recognized by the government and granted the right to buy and sell at wholesale and retail. It is of utmost importance that YOU also recognize that all the many things you will do for your business constitute a "REAL JOB" and not merely a pastime. What you believe, you can share.

When you carry yourself with an awareness of and respect for the work you do, others will be more likely to take notice of your work in a positive way. If you take the attitude of "oh, its nothing...." or "this old thing?" then others may well do the same. Although we were taught as children that it is rude to promote our own worth and "blow our own horns", we must as entrepreneurs learn how to do so in acceptable and effective ways. In doing so we can choose to be ambassadors of creativity, or mere shameless pitchmen—it's all the timing and the presentation.

As both Promoter and Artist, you will "on duty" whenever you go out and about in the world. Carry business cards with you at all times because you never know who may cross your path. Because we make wearable art, we are in the fortunate position of being able to advertise what we do without saying a word.

Remember that others who wear your work are also promoting it. If your best friend wears a lot of your necklaces, make sure she has business cards in her wallet for those who might inquire. My mother wears my jewelry at work, and has been the source of quite a few sales for me!

Business cards should identify your work and also point the way towards further information about obtaining more of it. It needs to contain your business name, any image or logo, and contact information. I show my e-mail address, my phone number and my web site URL. If you work from your home and don't want to give out your street address then get a Post Office Box, and use it for your business contact address.

You do not need to list a physical address on your card unless you have a storefront or gallery and want people to be able to locate it. You may also choose to add a few words identifying what you do. Or, use your pictorial image or logo for this purpose. Your business name and logo are part of what is called your "Corporate Identity" and can be used in many places to make your business memorable.

Now that computers and printers are within range of home users, jobs formerly requiring an advertising agency and printers can be done "in house" for far less cost and with artistic potential that is unlimited. The home setup has the advantage of giving the user the ability to change designs or information and to do small job lots. I can print 10 cards at a time instead of ordering a thousand to get the best price from an outside shop. By choosing your own card stock, design and information, you can fine-tune a presentation.

Once you have a black and white master sheet, copy machines can also be used to create cards, packaging and display materials, labels and more for those without continuing access to a computer or printer. This master sheet can be created on a computer, with cut and press letters and designs, or hand drawn and lettered. Stamps can be used either in creating a master sheet or in customizing your cards and other paper goods once printed.

There is a computer program by Broderbund called "The Print Shop" which is of great use to entrepreneurs. It is inexpensive, versatile and easy to use. Images can be scanned, saved and imported for use with templates to create cards, brochures, postcards and more. I print display cards for earrings and pins that match the business cards, but with only my URL for contact information as shop owners often prefer to limit information given to customers.

Using another template I can create "headers" or card stock pieces that are folded and stapled to the tops of the plastic bags into which I put items. With a name, logo and contact information, a penny or two of packaging transforms a piece into Merchandise. This adds greatly to the perceived value and protects your items as well.

# Making Connections

Acomputer provides the home user with a treasure trove of tools. Beyond the in-house uses of record keeping, artistic design, and other practical matters, computers gift us with a huge increase in potential. The machines we can all easily access today provide a host of opportunities that are unsurpassed in our human history—including easy access to connections of all kinds.

With minimal help and training, anyone can open lines of communication. Those without a computer of their own can get online at a Public Library. Establish an e-mail account with a free host such as hotmail.com and be instantly connected to a World Wide Web of communication. You can limit it to e-mail, or gain access to informational archives, online catalogs, classes, expert opinions, libraries and museum collections. Fast communication can make buying and selling personal, and items can take on a customized fit, even when the buyer is across the world. But unlike a phone, you can reach out and answer whenever YOU choose.

Web sites are an extremely potent new form of advertising. In the comfort of your own space you can view items for comparison, inspiration, or purchase as millions now do, using sites like ebay.com or etsy.com and merchants including amazon.com. More merchants discover just how effective and efficient online advertising can be every day.

There are several ways a web site can be of great use in selling your art. First and foremost—you get exposure. What is seen and admired is more likely to sell. Presenting your business and your art online establishes the Reality of both in the eyes of the consumer. There are programs available that

make learning how to use HTML and web building tools an achievable skill, and these are written for those who are not programmers by training. Some are built into hosts like AOL that will "walk you through" what it takes to use these and even supply a space to "put" your page. These files that you build are stored in an FTP space, and most commercial hosts supply some of this space for each user. Those who want to have their own domain name can do so by contracting with larger hosts.

My choice of host is found at internetconnection.net where they keep sites up and running with a minimum of my effort. Beginning users can start smaller. There are many places on the internet that will host pictures, or sites; some will help you build them too! Do be sure you always read the fine print in any agreement as some places host pictures for no cost, but signing up also turns over the copyrights of the pictures to the host.

Whether you learn to build your own web pages, or contract with others who do that art, you will want to have an address that is easy to remember. Something simple to remember, short and relating to your business is a big plus. This makes it worthwhile for a serious businessperson to get a domain name. It shows intent to continue, and it makes it easy to find. Many hosts will help you register the domain name, and it costs very little to establish a web presence by comparison to retail startup and run expenses.

Once you have the address and a site is up, you will still need to announce that address to the world. Search Engines compile these and can be used to find all sorts of information and items, but you have to give them the information so they can give it to others. A very easy and quick way to do this is to use a site like addme.com to register with many at one

The Business Of Professional Art

time—they help you do this in exchange for a small link on your page. They even supply the code to be cut and pasted into the HTML of your page. To see an example, go to my index page at polyclay.com and look at link at the bottom of the page.

I build my pages using Microsoft FrontPage and Adobe Photoshop as the programs for editing HTML and graphics, and use a scanner and digital camera to capture pictures of my work.

It is not necessary to have fancy flashing letters, advertising banners, and Astounding New Offers at a successful site. It IS important to offer interesting content, to update once in a while, and to maintain contact with potential customers. Place and maintain a working e-mail link on the page so you can be easily contacted, and respond in a timely fashion.

Have pictures of currently available items, list classes or shows or demos you offer and remove sold and outdated information. You can also steer clientele towards items of interest to them. Many companies have an Associates Program that encourages the use of links to their site, and pays a percentage fee to the site owner when purchases are made.

A web site for artists is a work in progress, and will undergo many changes. You can also track statistics from the visitors to the site, and learn a lot. Used well, you can access the world, and still have time for lunch with other artists!!

# Creating Content

No matter how wonderful the ad copy, it is most important to have a visual presentation of your work. After all—we are creators of Wearable Art, which needs to be seen for best appreciation! This can be done with film or digital photography for large and small pieces...and it is also possible to use a flat bed scanner for small items such as fabric designs or jewelry, and other accessories. You can then use those images in traditional print advertisements, and also take them easily to the Internet. The higher resolution scanners provide better quality pictures, and some of them also include adapters that can scan transparencies, both slides and film stock.

A good flatbed scanner is wonderful choice for capturing images of smaller items. It is compact and easy to use, comes with its own software, and can be easily integrated with such programs for editing as JASC Paint, Adobe Photoshop, Corel Painter, and more. The light source is contained within the machine, so there's no tricky set up of the illumination as there is with a camera. You lay the fabric, paper, or other flat item down on the scanner bed, and click a few times following the directions that come with the software included, and you have a picture! This is then saved in the format of your choice; often .JPG or .GIF, and can be manipulated to crop, resize, and more. Special effects can be easily added and corrections made with a few simple clicks. What used to take hours in a dark room can be done very simply with computers now!

Comparing information on the computer equipment that is newly available can be daunting, but it is well worth it in the long run to do so before purchasing. I strongly recommend the book Digital Photographer's Handbook by Tom Ang for

its information on scanners, printers, software and digital cameras! It is well worth owning.

To scan a piece that is mostly flat is very simple. If the scanner lid is left open during the scan, the item will be lit but the background will be black. This can be an interesting effect if there is a lot of contrast, and can make removing the background pixels easier, making the item able to be "floated" over a background as though it had been cut out and pasted there, without the original background. If the scanner lid is closed, the light is better trapped, and the background will be the color of the scanner lid. Or, you can use a piece of decorative fabric or paper to provide a backdrop by placing it over the item before closing the lid.

With items that are more dimensional, it is not as easy to close the scanner lid and trap the light effectively. Again, you can use a piece of cloth to cover the items and the glass plate of the scanner, so that the light does not bleed out. I also have a frame that I use for dimensional objects that is constructed of four strips of foam core (you can also use cardboard or wood) cut to fit the glass of the scanner in length and about 2 inches in width. These are taped at the corners to make a light box, which is just an empty rectangle that is placed on the scanner. The lid can then be placed on top of this, and the foam board "walls" trap the light, illuminating pieces with surprising clarity and depth.

Another helpful trick when scanning many small items that are similar in size is to take a piece of card stock and cut out a rectangle a bit larger than your items. I have one that is 4 inches square, and I set the scanner outlines to only scan that part, and it takes less time and file size. Then I have smaller files to manipulate from the start—always set your scans to the area around the item with as little wasted space

as possible as even a small amount of area adds greatly to the file size! Pictures can easily be cropped after scanning and saving, but when doing a set of pictures, you can save yourself a lot of time. This is particularly true if you intend to do online auctions.

Scanning items at 72 ppi (pixels per inch, or sometimes dpi for dots per inch) is quite adequate for web use. Print requires much higher resolution (usually 300 ppi) and creates much larger files. Pictures on web sites should be kept to smaller files in order to allow pages to load quickly. I often start with a large file at a higher resolution, and make a smaller version so as to have access later to both. Files can be stored in the computer in folders to make finding them easier, or saved to discs. As you build a portfolio of images, build folders to organize them, and give files names that will help you find and use them (like the name and date of the event or the place). Not only can these images be used on web pages, they also serve as a way of inventorying and archiving a record of your work and the progression of your skills.

# In The Eye Of The Beholder

Scanners can provide easy access to images of wearable art that can be used in print or Internet advertising if the items are small in scale, but even for these pieces more traditional photography is still of great use. The image quality in 35mm film is far higher than even the best digital cameras and is still used for creating glossy print ads, most magazine and book publication, and for most larger scale reproduction. High quality (high resolution) digital cameras are now available at relatively low cost. Small dots of color called pixels are used to create the image without film and the more of these in a small area, the higher the reproduction quality of the image. (and the higher the ppi or pixels per inch).

A digital camera using 2 mega pixels will take images that work well on the Internet, but not for printing. That requires higher levels, with professional quality cameras being at 5 or 6 mega pixels. Even there, many publishers prefer 35mm film stock or slides. Slide transparencies are an actual piece of film that is mounted in a square holder for ease in viewing. They can be stored in plastic boxes, or in plastic sheets with pockets that fit into three ring binders. These are readily available at hobby and craft stores as well as photographic stores. When placed on a light box, these sheets allow you to view multiple images at once, which is very useful when showing them to editors or other professionals. Prints can also be made from slides, and used to show previous work to potential clientele. Slides are almost always required when an artist is entering a juried show or sales event. The first hurdle is having slides at all—many beginning artists do not—and the second is to have very good slides, ones that draw attention to the artwork and nothing else.

Commercial photography is an art form itself, and much care must be taken to get things looking their absolute best in photographs. Digital photos do not require film or developing, and can be to very good effect in assessing the setup of a shot, as Polaroid photos have been used by fashion photographers for years. Once the lighting, set up and other parts of the shot are established, 35mm cameras are also used. Using the skills of a professional photographer can be a very important investment in getting your work seen. Even those artists without a lot of cash flow can sometimes work things out using barter. Some photographers are also working on their own portfolios of pictures, and some may like the work the artist does well enough to trade for it!

Whether you take your own photos or hire out, be involved in the artistic setup of the shots. Part of what is being presented is the artist's own sense of style. Working with the photographer to set up shots in a pleasing display is the job of the Art Director or Stylist. I prefer to do this part myself; even if the artist does not perform this function, its still important to have trained eyes looking for stray bits of fluff, a misplaced fold, a part covered that is better shown—or the other way around!

Time and attention spent before the pictures are taken pay off in the final image. Good lighting is a huge part of the production of beautiful pictures, and is often done with indirect lighting and bounced light. White cloth or paper can be used to reflect the lights so that they do not shine directly onto the piece, especially when glare is an issue as it is with glass. Natural light is the richest, but somethimes needs augmenting with more.

I somethimes use a Digital PhotoCube setup for small items, which has stretched white nylon panes that velcro into a cube

The Business Of Professional Art

and diffuse the light from the two lights that come with the set. It works very well for photographing small to medium sized items. It also has a little tripod, folds up into its own carrying case, and was not expensive when I bought it at Amazon.com

When setting up a shot, remember to focus on the piece being shown. This is particularly true of jury slides---a common mistake is to show the art piece in a way that makes for a nice picture of things together. While this is effective in some ways, the purpose of jury slides is to showcase one piece. It is not desirable to have surroundings or background that distract in any way. Paper or fabric can be used as a backdrop. Many photographers use a gradated sheet of paper that goes from gray to black that goes both under and behind the piece shown, creating a seamless flow. Other colors are available as well, and it must be decided whether to shoot against light or dark backgrounds as the difference in effect can be dramatic.

Whether you choose to start with film or digitally generated images, the computer is very useful in post-production. Images can be altered, cropped, and used in many ways that were undreamed of 50 years ago. Pictures can not only be used to catalog your output, but also to create it. Picture postcards are one option for use in advertising or for selling as part of the line. Images can be used to create fabric as well, using computer prints on special transfer paper and fabric. The record of work that builds up over time when pictures are taken on a regular basis can be very illuminating as to the development of style and form, and bears testimony about the work that lasts long after the pieces have been sold.

# Show Time!

A sales event provides a temporary marketplace, bringing buyers and vendors together for the benefit of all, including the promoters. Craft Shows, Arts Festivals, annual community events. All can be outlets for sales of an artisan's wares. There are thousands of indoor and outdoor events scheduled throughout the year and around the country. A subscription to The Crafts Report provides a great deal of information to the professional on everything from upcoming shows to packaging supplies and sources of display items, and comes well recommended by artists in many different media.

It is very helpful to go to an event yourself before you decide to book a space. Take a good look to see if your items fit in with the others in terms of style and format as well as price. Selling wearable art is much easier if there is a crowd of consumers looking for that sort of thing. You don't want customers to be comparing your artwork to flea market finds and prices. It is best to try and sell high quality hand made work with other art around, and not in competition with used goods or very inexpensive imports. If you do choose to sell at a yard sale, flea market or swap meet, be sure to feature low cost items and be prepared for those who wish to make you offers of less. This can be a good way to start out at in a small way, or to move merchandise that is no longer featured in your line. Closeouts and seconds are often found at bargain rates at these events.

Most shows and festivals are booked a year in advance. Artists apply for spaces—many shows require slides and these are used to select those who will be allowed to sell. Many established shows give preference to those vendors who have been there previously, and also may limit the number of artists

in a medium. This helps to keep a good balance, but it also raises the competitive stakes. It is important to have good pictures of your merchandise, and also of your display setup. A subscription to Crafts Report Magazine supplies listings and ratings of shows, articles and information on business, and advertising for supplies, display materials and more.

Often outdoor spaces measure 10' by 10', as do many spaces at convention centers or other commercial halls. Smaller venues may rent table space only. Commercial canopies are available for purchase or rent in that size, and are used by sellers of all kinds at outdoor shows. I have an EZ-Up Canopy with a roof and detachable walls, and it provides shade as well as definition of the individual sales space. As a portable storefront it provides protection from the elements outdoors as well as the infrastructure on which lights, display frames, mirrors and signs are safely suspended.

These tents can be staked to the ground when set up on dirt, or legs can be weighted with canvas covered sandbags. Bags of kitty litter are easily obtainable as quick weights. Having an area with shade outdoors encourages customers to linger and shop. Small clamp on lights can be used to illuminate and focus attention to items that might otherwise be missed. Although the sun might be shining outside and indoor events have general illumination, it is vital to be a able to see true colors and detail, and lights make that possible. It is well worth paying extra for electricity at indoor OR outdoor events.

Tables and a chair are sometimes provided. These must be covered with cloth that drapes the table to the floor. You can then hide packaging materials and extra supplies underneath and out of sight. Small objects displayed on average tables cause customers to have to bend over for a good look. Why

not make it easier for them to see your artwork by raising the height using wooden risers or sturdy boxes on the table top, then covering with display cloths. Or, you can use four pieces of PVC pipe cut to the same length and of the diameter to fit straight table legs. These can be placed on the ends of the legs to raise tables. All display items should call attention to the artwork, rather than to the materials used. Stick with plain fabrics and a limited palette of neutral colors. Choose elements that coordinate with each other and with your artwork. Straw bales and wooden signs are a better choice for Country style items, and won't work as well for Upscale Chic. Present a unified display in order to help customers understand what you are offering for sale.

Though its important to have a chair behind the tables for the occasional rest, stay busy and interactive with all who pass in front of your display. Make eye contact, smile, and talk about your media with all that ask. During slow times, resist temptation to sit and read, and instead take a look "out front" and get a customer-eye view of your area. "Fluff" and rearrange—it draws attention during quieter moments. Observe what works well and what does not, both for you and for other vendors. Pay attention to what customers are saying, and what they are buying. Remember that every sales event is also opportunity for Research and Development!

# Priced To Sell

The transaction of a sale is a simple thing, if the seller is prepared and the buyer is willing! Items of value are exchanged to the satisfaction of both. A wise seller makes sure that the customer is not only happy at the time of the sale, but also remains happy and ensures the items purchased are well made and hold up to use. Enclosing the items in a protective bag or box at the point of sale gives you the opportunity to enclose a business card and a receipt, and both of these help the consumer remember how to find you again. Happy customers who know how to find your work become repeat customers! You can purchase plain bags and use name or logo stamps to create your own personalized and distinctively memorable bags for use at shows. When people see them being carried by other buyers as they walk around, the bags serve as advertising.

Make it simple for someone to purchase items by clearly marking prices. If it's hard for them to miss your merchandise due to great displays and easy to find the price, they are more likely to buy. Use tags or attached cards that identify your business and clearly state the price of the item. People will not always ask, and prefer to look and evaluate before committing much. Signs that list prices of items are good, but it is also a good idea to mark individual things. Prices can be written on the backs of tags or cards, or printed on commercially available label sheets used with your computer printer. Knowing the price often makes the sale for an undecided customer.

But before you can tell the consumer, you must know how much to ask. The value of anything has to do with how much it would take to make you part with it and how much anyone

is prepared to offer for it. "What the traffic will bear" is a factor in pricing. (This is also known in some sales circles as "what'll ya give me?" and often these venues do not feature hard pricing, but favor haggling.)

Another factor in price is cost. As a manufacturer of a salable item, the artist has to track the expense of all the items that go into a particular piece. Some bits may be antiques or unique, no longer replaceable at original purchase price, and that too must be considered. Do the math to figure out what your materials cost, whether it's by weight or by yardage. Also calculate the cost of any packaging materials.

In addition to this amount, you add labor—that's the money for your time. (Your own labor is not deductible on your Schedule C Federal income tax forms. Your supplies are deductible.) When figuring your labor costs, you need to focus on time. How long does it take to make the piece? Are you doing production line work that can be streamlined and made more time-effective? I find that the first time I make something new, it takes far longer than it does when I have it down to a Process. There are many ways to do this, starting with making your tools and supplies for any tasks easily available to hand so you don't have to get up and get things as often!

Also, doing things in multiples cuts down on the time. Pay attention to the parts of assembly line processes that seem bothersome or annoying and there's usually a way to make it much easier. When you are comfortable with the amount of time spent on your work, add up the hours, and multiply by what you consider A Decent Wage for your skills. This part can be a little tricky. Beginners at any job do not usually command the wage that those who have many years of training and expertise. However, as skills grow and

production speeds up, the amount earned increases too.

Then take the cost of materials and labor and add them together. Add an additional 10% of that figure. This is your margin for the costs of doing business and promotion, unforeseen expenses, and profit. The total that you get is the wholesale price of the item. A store or gallery that buys wholesale will then mark up that price, often by 100%, thus doubling it. Sometimes the markup is higher. This part of the price covers the store owner's costs of doing business, such as rent, insurance, salaries of sales people, advertising and more.

The retail price should be one that the market will bear, and not too far out of alignment with prices of other goods for sale in the same media. If you sell to both retail and wholesale clientele, be sure never to undercut your commercial buyers by offering the lower price to your retail customers.

# (Cost +Labor)+10%=Wholesale
# Wholesale x 2=Retail

# The Point Of Sale

Making your beautiful, well made and presented merchandise available to your customers in an inviting, enticing way is the first part of making sales. But even the most fabulous offerings, presented along with the information about its qualities (and price) must be evaluated by the customer and either accepted, or not. As salespeople of any kind of goods and services know, the first part of this magic trick (wherein the items and the payment swap places) requires having customers available in quantity, as only a percentage will buy. They must be both interested in the goods and capable of making purchases, and it's the merchant's part to capture the interest and ease the transaction process.

Speak with the customers if they show interest or have any questions, but do not make the mistake of pouncing on all that wander too near because this can frighten them away. Think about birds flocking when there's something interesting. People do this too, and go to see what the others are looking at when they are shopping, but they can all be startled into flying away.

Cultivate a sense of ease in interacting with people, allowing them the freedom to look closely at your work and enjoy it, and wait for their signals to tell you when they are ready for more information or encouragement. These include looking around for a sales person, or just making eye contact, by asking questions directly, or making statements that show interest. Clearly label prices so that they can decide if its of real interest before they connect further—or walk away, because many times they won't ASK about unmarked items and you may miss an opportunity. Shoppers who are looking closely are powerful magnets to draw other shoppers. Your

displays must offer themselves up to the buyer, but not so freely that anyone runs off with them because "slippage", as theft is sometimes called in stores, is a risk in sales. Its best to have more than one set of eyes to watch over storefronts, show booths and other venues. When speaking with customers, do make eye contact, but also watch what is going on around you. Shoplifters often work together in teams, with one person to distract and others to take items.

When the customer decides on a purchase, take the time to write up a sales receipt. These are available in books from office supply stores, or can be custom printed. You can put your own information on them with labels or a rubber stamp as well—this gives the customer a reminder of what they purchased and from whom. It also allows the vendor to track not just the monetary amount of sales, but what items are selling, and this information is of value. Receipts also allow for easier accounting at tax time.

Give the customer a bag to hold their purchase safely, and use tissue paper to wrap breakable or very precious items before bagging them. This not only protects them from damage and loss, it adds to the perceived value to show care for items. It also presents an advertising opportunity—as that customer walks around carrying a bag with your company's name visible, others wonder what's inside and what your company might be selling. This helps to pique interest and to remind them of your existence. Bags can be inexpensively printed or hand decorated by the enthusiastic entrepreneur. (Rubberstamping and other bag decorating techniques can be sub-contracted to youngsters who want to earn a bit of spending money too!)

As you are serving the customer, do praise their good taste, and point out any items that might also be of interest ("This

barrette and earring set matches that necklace, did you see those over here?" ) as you are wrapping and bagging their purchases. Give them a sales receipt and a business card with your contact information.

Some artists also have a Guest Book that people can sign to be included on any mailing lists, which can garner you the contact information of people who are not yet customers. Contact information can also be taken from the checks received. When taking payment, always look at the information on a check to see that it's completely filled out. Get a drivers license or ID number as well. Make sure all credit card transactions are properly concluded, and that the card is signed on the back by the cardholder. When taking cash, hold the amount given in one hand until the transaction is finished. This way there's no quibbling over "I gave you a $50 bill." Or was it a five? Make change and count out the difference to the customer so that all are satisfied with the account before tucking the bills into your pouch or purse which should be worn on the merchant. It is never a good idea to leave purses, money boxes, or valuable items like cameras lying around unattended.

Start out with enough change to be able to deal with any transaction capably. If you use up all your change too fast, have someone go out and purchase something for you with a larger bill. This makes you part of the money exchange flow, and is better than asking your neighboring merchants if they can make change for you. Maintain a professional and friendly attitude and smile even if you are tired! This is particularly needed whether things are going smoothly or not. The more pleasant you make the customer's experience, the more likely their return to shop again. Last but not least, when a customer invests in your art, say "thank you". Courtesy makes everything we show look a bit better.

# Hosting A Show

On one end of the show spectrum are the Conventions, Trade Shows, and other Events where participants from around the world meet to showcase their goods and services to sell them to others. Whether these take place on an international scale or focus on vendors from a particular country or state, the principals of promotion share much in common with more local events. This includes getting the word out to interested sellers and buyers in such a way that you get them both together at an agreed on time and place. Local show promoters book venues such as county fairgrounds, hotel convention rooms, and city convention centers or merchandise marts years in advance, particularly for established shows at popular times like the Christmas Holiday Season. Many cities and towns have local fairs or festivals that rely on volunteer labor for all of the organizational and other work, and this can be a wonderful way to learn about the efforts that go into "putting on a show".

With the paperwork of finding a site and getting all necessary licenses and permissions, the mechanical details of electrical and water needs to vendors and sanitation requirements of all and including the hostess skills involved in putting vendors and customers together in a satisfying mix, the pre-publicity, and the security issues of keeping an eye on everything during the event, there is always more work to be done than there are people to easily do it! Volunteering your efforts can give you much needed experience that allows you to not only learn valuable skills, but also to avoid very costly mistakes should you decide that YOU want to host a show—starting on a much smaller scale!

Two ways to go about this include Private Shows and Trunk Shows. One difference between the two is that a Trunk Show is a single artist or company that is invited to have a special one or two day showing of their goods at an established business. For instance, I plan a Trunk Show this year at my local yarn and fiber store to showcase buttons and other wearable art embellishments. As the Designer/Sales Rep, I will be there for one afternoon, talking about and showing what I do, and helping to sell it to all the interested customers. Artwork will be displayed temporarily at the store, and any sales will be made through the store itself. At the end of the day, totals are tallied and the agreed on split of the sales take place. This can be 50-50 or whatever percentage has been agreed on previously.

Customers benefit from trunk shows because they get to see a much wider selection of the artist's wares than are usually available, store owners get an influx of new customers that come to see the show and may well come back again another day, and artists have exposure to both existing and new clientele without having to do it on a daily basis. Many times a happy owner will place a wholesale order for the items in which their customers have shown interest, so Trunk Shows also allow for a trial period that may well bring further orders down the line. This differs sharply from consignment in that the items are not left in the store for sale without the representation of the artist. Consignment may be a further element of the agreement if desired. It is often preferable for a professional artist to sell work outright at wholesale rather than to place it on consignment, but this is something that has to be weighed in each individual circumstance.

A Private Show can be done two ways. Taking the wares of an artist or group of artists to someone's home or meeting place where people are gathered is the more informal version.

There have been occasions around the Holidays wherein a twenty-minute show and tell in the Teacher's Lounge was well worth the effort to box up a selection and whisk them in and out. Inquire about selling to your family's work mates; sometimes there's an existing company Christmas gift sale, or a more informal arrangement can be made as is done with Avon and Tupperware sales. Sometimes a Home Party can be a fun and inexpensive outlet.

For those who are willing to do the organizational work involved, creating a temporary gallery and showroom in a private home can be very satisfying and well received, especially if done seasonally and a reputation for excellence is built up.

Two wonderful artists that I met in California put on a Christmas Holiday Show and a Spring Show every year that featured 6 to 12 different artists who would bring their items and set up for a two or three day show. One of the organizers is connected to a real-estate agent that allows them to use one of the available empty listings or the Victorian building which houses their offices, with all desks and such moved out of the way.

Preparing the area and cleanup afterwards are things willingly done in order to ensure a return invitation. Participants pay a percentage of sales to the organizers as well as a small fee up-front to help with the costs of advertising and to provide snacks, tea, cider or wine as another part of the festivities. All vendors do their part to invite their own existing customer base and bring in additional new people. When done annually, happy customers bring their friends!

# Create Effective Publicity

Arts Festival, Craft Show, Gallery Event, or Boutique Trunk Show—no matter what event you may have gotten yourself booked into, congratulations! There's no better prod to artistic motivation than having a show... and a deadline! With details like fabulous merchandise and visually enticing displays already in place, it's time to consider promotions. The customers who want to buy your art need to be informed that it's available!

If you are part of a larger venue, the organizers will be doing some advertising for the event itself, but you should do your part as well. Distribute flyers or send postcards if supplied by the organizers, and if not, create your own and alert the clientele on your mailing list. This is made up of all the people that have ever bought something from you, so copy those addresses down from checks! Also, having an address book with you so people can add their information to be notified of upcoming events is a good idea. Make it a beautiful book, and customers will be glad to sign up for your notices.

In preparing your publicity releases, you will need to remember the old adage from English/Journalism classes, and include Who, What, Where, When, and Why. These crucial items will be relayed in several different ways. A poster or postcard should convey those things in simple terms, with a picture to attract attention in the first place.

Fewer words bring emphasis to the factual information— "The Incredible Wearable Art Show and Sale! The #17 Main Street Gallery in Mytown CO, Saturday June 17 from 10AM till 6PM" states the most important parts. Additional information about those appearing including a listing of

any artists, musicians, and other attractions should also be included. This is where Name Recognition really starts to help draw interest.

The same informational nuggets with a few more details are needed when it comes to television, newspaper and radio press releases. Try to keep it contained to one or two paragraphs. You want to highlight the names or events of interest, as well as repeat the date, time, and location. If there are any sponsors, they should be listed as well. Always double-check the spelling on names and on all information before committing to print!

Read through your paragraph several times, including reading it out loud. Don't repeat adjectives. Instead of using "wonderful" twice, try "fabulous!" Many people have a great deal of difficulty writing about their own work or their selves, as we've been taught its "rude" to blow our own horns. Put that aside, for when it comes to publicity, you want to be sounding bold as brass! It often helps to write in the third person—pretend it isn't YOU, writing about you, and go ahead and say those positive things!!

*Here's a fictional event's brief description:*

"The #17 Main Street Gallery is presenting an Incredible Wearable Art Show and Sale that features the outrageously colorful work of ten nationally known artists. Their wearable creations include fiber arts of all kinds and fabulous beads and jewelry from Sarajane's Polyclay Gallery, hand dyed and painted textiles from The Gilded Guild, and the spun and woven wonders from the Alpaca Group. Buttons By Betty showcases vintage jewelry and collectables from the past. A huge collection of hand-tooled leather boots by He's That Cowboy will be on display, and all the artists will be available

in person to speak with the public. The doors will be open from 10 AM until 6PM and the jazz music of The Local Trio will also be featured! Admission is free to the public."

This can be submitted to many places including the Events Calendar of your local newspapers, college newspapers, and other local magazines for inclusion, and many are free of charge. Special Interest magazines also list upcoming events, but you have to get the information to them quite a bit ahead of time to allow for print schedules, so plan ahead.

Think about your target market and what they might be reading or watching. Newspapers will often do stories about artists for inclusion if given a peek at the work and a bit of information already there for them. Sending a release to the Fashion Editor or the Special Events Desk just requires that you start to look carefully in the papers and magazines where they often list the information about how to contact them.

Maintain a list and you will have an easier time of it. Once you begin to make contacts that know you, its even better! In addition to print media, send your releases to radio and television stations that have Events Listings. Sometimes further publicity will come from these seeds, especially if it's a slow news week, and if you help it along a bit. Be personable and persistent, and send out notices in waves.

After the brief description, try your hand at filling it out further. Add some descriptions of the art, or statements from other artists. Pictures speak loudly…digital pictures can be included and you can advertise your event from a web page very easily if you turn the pictures and text into HTML. If its not a skill you possess, barter with someone who does, because if you have the information available on the world wide web, it is easy to send the URL to those you'd

like to contact! Covering ALL the bases of public contact includes private mail, public print media such as newspaper, magazines, newsletters, and flyers or posters, as well as television and radio. Don't forget your public television cable stations locally as often they are looking for good ideas and need content. A feature on your event might be of interest, and result in great free publicity.

# Giving It Away

There was once a television advertisement for fish sticks that asked customers what else could be done to improve the popularity of the product. A sweet little old lady said demurely "You could GIVE them away..."

Odd as it may sound, this is good business advice in some circumstances. Samples can pique a consumer's interest in a very personal way, and get their attention to your product. After that it becomes a matter of how well your products suit their tastes and needs. If you are confident that you have a great line to show off, then that's exactly what you need to do—give it away. Or rather, give some of it, and in the forms you choose. A small sample sent to the right buyer, editor, designer or other Person In Charge Of Choosing can bring in far more than its retail value in good will, attention, and potential. These wholesale value of these items are also considered part of your advertising costs, and a legitimate business deduction for tax purposes.

Photographs of your work can be made into postcards at low cost using a computer and printer, or use one of the professional services that print them. You can give them to potential customers whenever you meet someone that you would like to remember your work in more detail than your business card conveys. Tuck a free postcard or other giveaway advertising item in the bag when you have an especially good sale as well. Also use them in mailings to garner interest in your upcoming sales or special events. When I do shows and other large events, I will often give very well-behaved children a bead or tile from the $1.00 basket. Particularly if they've already spent some wistful time riffling through them while their adult companion shops, this very small gift

on my part serves many purposes besides just being nice (and possibly memorable). By making the experience a positive one we encourage good things from everybody's behavior. Shopping can be fun and then they are more likely to do it again later. Repeat business is a good thing!

Charitable donations of work for auction are another tax deductible form of giving it away. Local organizations whose work and aims you endorse can be supported in many ways. One is to create works that are auctioned in annual events such as our local Humane Society sponsors. Special fund-raisers like our local Symphony Orchestra's "Art of Music" event called on 27 artists to decorate a violin, and we participated. By giving away the time and supplies required for this piece, we gain publicity, build community ties, support the local musicians, and more. When attending a charitable event at which you are a donor, make sure to have plenty of business cards tucked away but easily accessible.

Wearable artists may also wish to supply accessories for the seasonal fashion shows of other designers. This can be a fabulous way to get your work seen by people who purchase. Making connections with others can lead you to all sorts of potential outlets, if you stay on the look-out for them. A conversation with someone who is involved with the local community or college theatre can lead to having some of your work seen by thousands and mentioned in the program if you are willing to loan it for use.

Photographs of your jewelry seen accessorizing the Up And Coming Fashion Designer's newest collection can do a lot for your name and business potential. Offering to bring pieces in to the photo shoot and to help with the details of dressing can be fun and educational. It also helps in keeping track of your items! However, when donating or loaning,

be prepared for damage or loss. If it happens, write off the wholesale value of the piece and don't fret—its just part of doing business.

Donate your time and knowledge too. Pass on some of the inspiration and help that you have received in your artistic journey. Volunteer to do a show and tell at a local school or community organization. One hour of your time can make a difference in the way someone understands or perceives art and aesthetics, and the creative possibilities available to us all. There are summer programs for youths at libraries, YMCA, county fairgrounds and park services in most towns that are always looking for interesting presentations.

Think about what you can offer and which groups you'd like to benefit and you will be able to give something personal and valuable to your community. If we give some good things, we end up getting some good things back in return. That's the basis of the Potlatch ceremony celebrated by some Native American tribes, who know that by giving you improve things for everybody—including yourself.

# Keeping Track

To the outside observer, it may seem as though once the start-up details of business are in place there's not much left to do but sit back and rake in the profits. After all, once you've stocked the shelves, put up the sign that says "open for business" and the customers are there, what's left to do? Why, more of everything, of course! More items need to be designed, created, packaged, displayed and dispersed to the paying clientele. And in the course of it all, information that is vital to your success must be tracked. Even the most casual of sellers needs to keep track of income, so that all legal taxes and license matters can be dealt with in a timely manner. Get in the habit of keeping track, and all the book-keeping details and the deadlines are much easier to meet.

Whether you use your or an old fashioned accounting in pencil on paper, it's a very good idea to have more than one copy. It's a good idea to have files stored in separate physical locations and that particularly means not just in your head. Keep important information about your expenditures and your income in a folder on your computer or paperwork in your file cabinet and keep a copy somewhere else as well. A disc kept in a separate storage area, or on an external hard drive, can back up years of information. A Safety Deposit Box at your bank is one relatively inexpensive solution, or a small fireproof safe with copies of important records; having copies of your records can be very useful.

Backing up your information is the best security policy you can have, and that includes more than financial matters. I remind myself frequently to make backup copies of book manuscripts, articles, and designs that I want to keep available. Make a print-out or a copy of the files and you wont lose

the information just because the computer has a "fatal error". Keep a box for vital scraps of paper; you don't have to stop designing on restaurant napkins or writing songs on receipts, but you DO need to have a place to put them where they will be available later. Small papers get lost much more easily than large boxes full of small papers do!

Organize once in a while and fill up a loose-leaf binder with plastic page protectors, which are like pockets. Put those little bits of scribbled information or notes in a place you can use them later. When organizing at the end of the fiscal year, you can determine whether they are treasures or trash needing relocation. In addition to keeping records of money flowing in and out of your business, it's also wise to keep track of the details about suppliers, customers, and those with whom you do business. Train yourself to be in the business card habit. Give YOURS out to others, and when you buy something, or find an interesting outlet or source, take a business card from them.

Keep a file and when you need to reorder, it really helps if you already know the name and contact information of that vendor, as well as the item of interest. By keeping the shipping copies of your orders, you can easily get more of the Thing You Need, but if you don't remember where you got them, or what they are actually called, its much harder. If I find a company that has some item I buy that is very useful, I write it down on the back of the business card. That's so I remember they are the store with "dyed feathers" even though it was a fishing tackle store, which may not resurface in my memory a year later. If you jot down the name of your contact person at the company, and any information relevant to the encounter, it can make any follow-up MUCH easier. If you have a question concerning an order, you can ask to speak with the same person. When you come across in a

professional and competent manner, and treat others with courtesy, you are more likely to be treated that way yourself. Its also true that many people are just a little bit more helpful to those who are "not strangers".

You can track all of these things by hand, or by using readily available computer programs like Microsoft Office Suite with Word, Excel and Access. Many people use QuickBooks, TurboTax and other programs specifically created for small businesses and individuals. By inputting your information (whether you do it weekly, monthly or in one big swoop at the end of the year) you have the advantage of the computer's ability to use all that data in many ways and it is both fast and accurate with the numbers.

With a database of my suppliers and customers, using a function like Mail Merge makes it a breeze to produce beautiful mass mailings, and to pick very specific portions of the list, like "Bead Stores", or perhaps "California customers" if I'm doing a show in San Diego. Use them to print letters, cards envelopes or mailing labels with little time or cost. If you have all your numbers ready to go, these programs will do much of the work when its time for inventories, sales analysis, and tax returns. These programs all have built in help sections and "Wizards" to guide you through their use. If you have any difficulty that can't be figured out yourself, consider about taking a class through your local community college. They also offer classes in marketing, photography, Adobe Photoshop and other programs that are very helpfu to a professional artist. Many areas also have Adult Learning centers or Developmental services that offer classes. This is also another area where you can barter for services, or hire them outright. You don't have to do everything in every part of your business. You just need to keep track of how it is being done.

# Blazing Your Trail

The personal touch can make a big difference in how you (and your business) are remembered and treated. Doing repeat business such as your banking with local merchants can make the experience far different than the impersonal service you receive from half a world away. When possible, be involved in your local economy to the benefit of all! When you do business in the world outside your geographic area, remember that the things that are the hallmarks of "neighborhood" transcend mere place geography, and take the opportunity to extend the boundaries. This is your opportunity to make those vendors and purveyors of services part of your own "circle" and treat them with the awareness and courtesy you'd want them to find in your own neck of the woods. The world today is a much more connected place than it was a century ago. Your business and your reputation as a professional personal is a global one, so treat it accordingly wherever you are.

This is particularly important to remember when using the Internet. You are not the only one keeping track! Articles that appear in newspapers and magazines are very often archived, and so are posts to newsgroups and blogs. It is important to remember that if you are a member of any online message group that what you say can be seen by all who are looking, and not just the few that respond. The Internet is a very public place, although it has the feeling of privacy that can invite unwise comments. Behave as though you are about to be held accountable for your words at any time, and the Internet can be a very powerful tool for your business. Membership in online interest groups can be enormously beneficial and when you behave in a professional, courteous manner, people around the world will know it. Although many groups

discourage too-frequent advertising, almost all allow a small signature line as part of your posts, and this can be set to advertise the location of your web site. This way every time you speak about on-topic issues, you are also leaving a small calling card, where readers may find your business.

If you have not already done so, use one of the search engines online and look up the information that is publicly available about you. This is sometimes called "googling" yourself if you go to Google.com and search for your name, or the name of your business. To see what is archived from you in online postings, use the Groups advanced search option and look for all posts containing your account name as the sender. Or, see what others are saying about you by using your name as the key search words. There are often many links that have nothing to do with you but is very interesting to find out what does. You can sometimes remove your own postings from archives, but not those made by others. Although you may never see them, many thousands of people read newsgroups. Your reputation is made by your behavior, and when you participate in groups in a positive way, it is a part of your persona that becomes known everywhere that the World Wide Web connects.

If you participate in online auctions, your clients have the option of leaving "feedback" points and comments. Read what is said about you and know that others do too. Bidders avoid those sellers with negative feedback. It is an immediate way to tell if there are consistently problems with quality or shipping times; be very careful to always keep track of your auctions and deal with sales in an efficient manner. Encourage your winning buyers to leave you favorable feedback by treating them well, and by leaving them feedback after payment. Many times, a positive transaction will lead customers to put you on their "favorites seller" list, and they

become repeat buyers. Some auctions allow a link to your own web site, but others do not. eBay does not allow links on the actual auction item pages, but does allow a link to your About Me page, and from there you can link to your own URL. Having items available at auction and sales sites like etsy.com, justbeads.com and eBay.com can significantly increase traffic by increasing the number of people who know where to find it. There are far more sales sites than these few I've listed, so do a little on line research and see how others who work in your chosen medium are presenting their designs, and where. Use those search engines!

Exchanging links with others also helps to "light up" the pathway to your own displays. People follow the trails by clicking through the links on sites and find some amazing things; so make sure your site is one of them. When you find sites with information that is goes well with yours, ask to exchange links with the owner. This increases the visibility of both sites, and improves search engine ranking too. There are also "web rings" for many areas of interest, and by submitting your site as part of ring, people interested in that subject can easily find more sites—including yours. Make sure that online groups or rings that you join are in the areas that fit well with your work, and networking on the 'Net can work very well for you.

# When The Answer Is "No"

There are many important factors involved in the success of any business. In addition to quality product, marketing presence, canny investment and hard work, there's something vital that is often overlooked in the early stages. A critical key to success is the ability to deal with failure in a positive way.

Life and the business of art are full of questions, and sometimes the answer will not be the one you wanted to hear. To deal with the changes required in running a professional endeavor, you need to remain flexible enough to accommodate the vagaries of suppliers, customers, materials, technical applications and marketing. It is a kind of juggling act that requires patience and practice. When you add in factors like weather, economy, and other issues that have effects on both local and global levels, there are times that with the best of intentions and efforts you will not be able to achieve the immediate goal.

Some potential issues can be foreseen and backup plans made. Its good to have more than one supplier for a critical part used in creating your merchandise, or stockpile enough that a temporary shortage from the source will not cripple your ability to meet orders in a timely fashion. Track your inventory well enough that you don't run out of things. I find it is better to have what is needed for projects readily available, and then the work can flow with no lost time. Having to run to the store for more of something, or ordering and waiting for delivery, is not efficient especially if they don't have it in stock. Being prepared ahead of time can spare you having to make substitutions or track down replacements at a busy time. But if that does happen, use the

time positively and keep track of all the potential suppliers or venues you find while doing your research. Learn new applications and techniques from the variations that come of necessity. They can be immensely valuable, even though you did not originally choose to go looking for them.

When a particular ingredient or material or tool is no longer available, we know that it must be replaced with something or done without. When a customer does not choose to purchase an item, we remember that there will be another customer on another day. If the Big Show is rained out there will be others, more opportunities for commerce and trade if we can just continue till then. This is a necessary optimism for all merchants, whether they are selling alfalfa or watercolor paintings.

Just as farmers have seasons when the crops don't show much growth, there are fallow times for artists when the Creative Muse inside says "no". It is vital to remember that this is NOT a "failure" of the creative ability. It is a needed part of the cycle, in which much can be happening though the results are not produced on demand. It can be very aggravating when the flow of ideas and inspirations and abilities are not going well. And while its not good business to just stop whenever things get difficult, it can also be non-productive to continue to push when something is jammed.

Sometimes in order to get perspective on a problem, we need to walk away for just a bit. Much like trying to think of a particular word, sometimes the quickest way is to do something else—then the word pops right out, instead of hiding for days. This is true of creative abilities as well. There are times when its best to do something else. If the answer is consistently "no", then switch to a different question for a while.

The Business Of Professional Art

Or just let the issue sit quietly for a while and take care of other matters. Reorganize your environment a bit, or take a walk and look at different surroundings. When there are things that you cannot affect, make a list of What Needs Doing and choose an item that can be done. Any task successfully completed will make you feel a little bit better about trying again on a more difficult matter.

Give your mind different input through where you are or what you focus on seeing and hearing. Listen to music with your eyes closed, go to a museum or library and view beautiful images. Choose a subject you don't know much about or appreciate a beloved one anew. By adding new sensory stimulation, or by backing away from the existing ones for a little quiet time, you can come away with fresh energies and outlooks. Sometimes the process is difficult but along with change comes opportunity, and fresh inspiration, and with practice we increase our skills.

Be patient with yourself when things are not going smoothly, and remember that success requires the ability to both persevere and to change.

# Psst... Pass It On!

In the old European Guild Hall system, a person began their professional training as an Apprentice; an unpaid worker who does whatever is required in return for the opportunity to learn the Trade and sometimes receives room and board. After a period of several years, a skilled worker can become a Journeyman and then work towards being a Master of that medium. This important professional step forward required creating a Master Piece, recognized as such by ones Guild.

It also required time spent teaching those skills to the new generation of apprentices and journeymen. This ensured that abilities and techniques were passed on, and in the days of secretive guild halls, this was especially vital. Many formulae for dyes, glass colors and glazes, and techniques used with building and creating have been lost to all artists through lack of being passed to someone else before the inventor's demise.

The other important reason to instruct others is to refine and hone your OWN abilities. By organizing information in such a way that it can be shared, you make it more clear to yourself too. The questions that are asked by students and the differences that show up in the course of a class can be jumpstarts to renewed creativity, and offer different perspective. Quite often in the course of a class, the instructor will pick up some new way of using the material, or find out about a new tool, or a variation of use with an old one. Students learn from each other as well; its an opportunity to pool knowledge on many levels!

By instructing for a fee, a professional artist has the chance to increase their earning base by adding a "product" that is

renewable—unlike a necklace or a suit that is made and sold once, a class can be taught again and again, and often in less time than it takes to make an entire finished piece. There are many ways to present this additional product, including: personal appearances (classes), television appearances, instructional videos or DVDs, CDs, web-cam lessons, books, how-to articles in magazines, booklets, and kits. Each has its own specific issues to address when trying to make a start, and we'll discuss them in upcoming columns here.

The best place to start is with Doing What It Is You Do… Do it to the point you are getting good at it AND capable of the skill base so that you are still learning new things that enthuse you. Take the techniques you have learned from others and make them part of your own style. No matter the media, know the names of your supplies and your tools, and know the safety information and the physical properties of the materials used.

When you talk with others about your art, you are educating them about it. Take that further when you are ready, and advance to 'Show and Tell". Do your art in front of someone and talk as you do it, telling them what it is you are doing. When you find others with a real interest, instruction becomes a matter of sharing, and its fun! Practice those sharing skills with one or two others at a time before taking on a class booking of any size. You will quickly become aware of any tools, supplies, or other items that you are needing to really get the idea across. Its much easier to show someone how to knit when you have needles, yarn, and scissors, as doing the motions with just your fingers while you talk is not nearly so clear!

People learn best when the see and hear together, and especially when they get their hands on the things in question. Many

artistic people in particular are tactile learners, who only "get it" when their hands are involved. Others need written and oral instructions, and some just seem to pick things up by osmosis, just by being there! As an instructor, you need to be prepared for each kind of learning need, and the best way to do that is to practice.

A great way to get that practice is to get together with neighborhood kids, your friends, their friends, or with official volunteer groups like Scouts, Community Recreation Centers, Senior Centers, and schools. Offer to do a small demo about your work, and get the interest aroused for a class. County and State Fairs often have artists demonstration their work, as do local neighborhood and town events.

If you have a local group of people who do work in your medium, share information and practice by showing each other. "How did you do that?" leads to the best forms of learning, when you are both willing to share the experience! Then, when answering, the process is broken down into its components steps. You may not even be consciously aware of the number of steps, or the order in which they progress until you tell someone else!

The Business Of Professional Art

# Organizing A Class

Some classes form themselves naturally. A group of friends or colleagues that want to learn a skill find out that YOU know how to do it, and are willing to share what you know. This process can be very informal, with a get-together in someone's home or at the local library or community gathering place.

Work parties have long been a way to share abilities and knowledge while everyone enjoys the communal project experience. This is true whether it's a barn-raising, a quilting bee, or a group knitting project for tiny babies or soldiers in the Armed Forces. Some sewing circles or bead groups will work companionably together while one member reads aloud, or while lively conversations on Important Subjects occur!

When its time to hone specialized skills, taking a class from a professional in that field is an excellent way to get information and techniques that can be utilized later. As that professional instructor, there are ways to maximize the learning experience for everyone involved, including you. A wonderful facet of teaching is that everybody has things they learn!

In order to attract students to a class, you need several things. One is a place to hold it, with adequate room for everyone, good lighting, work surfaces and not too noisy. Convenience is also a factor—many bead, fabric and fiber stores offer classes as a way to raise awareness of the potentials of their merchandise lines.

Its lovely to have supplies available right there. If they are

not, then it's up to the instructor to either arrange a supplier or to indicate to the students what they will need to bring. This is an important part of the class listing information.

It should include:

- Where and when the class is being held, both the date, the starting time, and the duration
- Cost of the class
- Who is teaching/offering the class
- What kind of technique or information will be covered in the class
- What students need to bring in the way of supplies for class
- What students need in the way of tools
- Contact information for students who wish to sign up

A picture or examples of the instructor's work or a finished sample of the project that is the class focus are also very important. These things are what "sell" the class. Potential students look at a lovely piece and say "I want to do THAT...." and a good instructor will show them how they can get there.

The information can be printed using computers. Even those who don't own one themselves can book an hour of library computer time and print out one copy, then take it to a copy center or office supply store to make more.

Flyers or postcards can be created and mailed to interested students, once you have established a mailing list. A nicely printed class description and a sample piece can be displayed at stores or galleries where you offer your classes; however samples should always be left with responsible owners who display class samples in ways that help ensure they do not

walk away. In less protected venues, use a print of a good photograph of the work. This is yet another instance where great pictures really pay.

When listing classes with a store, gallery, or other organization, be sure to work out many of the details ahead of time. This includes setting a minimum and maximum number of students, discussing cancellation policies, age range of students, who does the registration and takes the money, and when and how the instructor is paid.

Discuss also what exactly is being supplied by them and what is provided by you, and what the students are bringing. Who sets up the chairs, cleans off the tables, and has the key to the door? Is running water and electricity available? Check all these things out ahead of time. Check again on some things when you arrive ahead of the scheduled start time, so as to have time to set up. Is that extension cord still there? This can be a vital issue.

Long before the day of the class itself, do your publicity work. Advertise your classes anywhere that you can get permission to do so and you think there are potential students. Make sure the notices are posted where interested people can actually see them, and put the information on your web site as well. Use word of mouth and ask others to please tell their friends and coworkers about the opportunity too.

If you are teaching a skill used in wearable art, then make sure that you have some great examples that you and your friends and family can wear and show off to admirers. One beautiful bracelet, shown off over lunch by an enthusiastic wearer, can partly fill a "making charms" class.

If there is a local charity event you wish to support, consider

donating a "One Free Class" coupon as a prize or auction item that entitles the lucky recipient to your class! (They may well bring a paying friend or two to keep them company.)

As part of your handout information to your students in class, be sure to include a business card and a schedule of your upcoming classes. Satisfied students are your best customer base, and many will return to learn more as long as you continue to offer projects of interest.

# Creating A Kit

When you put together all the items necessary to complete a specific project, it becomes a "kit". Sometimes instructors do this in order to ensure that each student has the required materials for a class. Another reason to assemble a kit is to sell it as a stand-alone product in its own right.

Kits that are an adjunct to a class can be far more simplistic in organization because you will be there in person to provide instructions for use, and to answer any questions about "What's this stuff?" When packaging items for a specific class, think about the entire project from start to finish. Will students be supplying their own tools? Will the kit contain any items that need special handling like "keep out of direct sunlight"? Supply needed information right there so that it wont be forgotten in the bustle of class.

Make sure you have everything needed, or that you specify all items that are needed to supplement the kit. If it's a doll making kit, don't forget about the stuffing! If it's a beaded bracelet kit, make sure you have ALL the beads needed and the findings as well. Always include a little bit more than absolutely required so that if a bead is lost it's not a tragedy, and a little extra cord or wire. Fraying is not a big problem unless you have no room for errors or cutting off ends. When you have put all the items together, do the project in your head, starting at the very beginning, and go through all the steps mentally while you make sure that you have every item needed. Its much better to notice a step left out now. There may be items needed by everyone that are shared and it's up to the instructor to have them available for use or to let students know they are needed ahead of time.

When putting this kind of student kit together, the main requirements are practical. The interested customer base is already there and so there is no need to spend much time or money on display. Items can be bagged for ease in organization and handling and then passed out to each student if the sets are all alike, or individual choices may be present if you have color variety and different groups of items.

Be forewarned, choice is a wonderful thing but it requires extra time for those decision making moments. Plan that into your class schedule if necessary. Zip lock plastic bags are available in many sizes and can be found at the grocery store or purchased in quantity through companies like Uline.com and Bradley's Plastic Bag Co. at www.bradleybag.com

Some hobby stores also now carry several sizes of plastic bags. You will probably need a bag or a box for the entire kit, and any small items can also be individually bagged to prevent them getting mixed up or lost within the group of items. When assembling multiple kits this pre-packaging of parts can make it much easier. If there are four kinds of beads, a needle and thread and a clasp in each "bracelet kit" having your twenty clasps all bagged and ready to go makes it easy to drop one in each kit, then add the beads, etc.

A needle and thread can be made safer to handle if you put the needle through a business card or small piece of fabric or felt and then bag it separately from all the beads. Be sure that any sharp or delicate items are packaged safely. If you are repackaging from a bulk source into smaller amounts, use a suitable container and have all liquids or powders tightly sealed. Label repackaged items clearly, especially when they are of a chemical nature like dyes, paints or finishes, alcohol, hand soap and so on.

A kit for sale outside of the instructional setting needs to have its items both more visible and at the same time more protected from rough handling. It needs to be easily displayed in some way by the seller. Folded card stock "headers" that are hole punched in the center and stapled onto a bag allows you to seal the bag and make it less casually opened, and the kits can then be hung from hooks or grouped on shelves or in baskets. A header creates space for you to give information about your product and your company. You can print contact information there along with your logo and also list each item included in the kit. Give any special care information including fiber content or other identifying product information

Because you are not there to give any instructions in their use, you have to include them in the kit. If your how-to is brief, you may be able to fit it on the inside of the header. Anything more than a few sentences is best done as a separate document.

# Writing Clear Instructions

Written instructions for a project or technique can be useful in many ways; as part of a kit, handouts for a class, web tutorials, magazine articles, and how-to books. All begin with the concept of telling someone else how to do some procedure when you are not physically there to show and explain further. This starts with a solid working knowledge of the action involved, and then that is broken down into the steps that must be taken to achieve the aim. These steps must then be conveyed in progressive order and in an understandable way. It's crucial to avoid leaving anything out in the hope that the reader "already knows that part". It's also important not to be so wordy that the information is hidden in the flow! Like poetry, writing clear instructions requires paring the presented words down to true point of communicating the concept, and still making it all interesting enough that the reader wants to continue. This task of choosing and balancing words is an art form itself, and not all artists in other media communicate easily in the written or spoken word. It's a skill that can be practiced, like all others, and if you have a gift for it at all, it can be an enriching adjunct to your other forms of art.

An excellent way to practice is to talk out loud as you do the actual activity. Either record what you say in your memory or on tape. Start at the very beginning with what items and tools are required. Is there any preparation needed for best use or for safety? Tell the potential reader right away if a drop cloth will be required before you delve into the intricacies of paint splattering!

As you talk your way through the activity, each step will present itself to your awareness in a way that you may not

have consciously thought about and this will allow you to find ways to tell it clearly to others. Taking photographs or creating diagrams can be of as much value as the words, or more, if they can clear up any confusion. Pictures can indeed be worth a thousand words! In industry terms, these are called "step-outs" and are especially important to artists because we tend to learn visually or in a combination of ways. The most effective learning for many artists comes when they can hear, see, and touch at the same time for tactile or "hands-on learning". Step-out pictures and their accompanying instructions must be presented in a clear, un-obscured manner. Leave out distracting backgrounds and unneeded extras. This is true of the pictures and of the things you say.

After the action is completed, write down or transcribe the steps in the order that you did them. Rather than tossing it out in one big flow, use the natural progression to break it into manageable parts. If something is to be rolled out, cut, baked, painted, and then drilled, tell about each of those steps separately. If you have to pick something up or put something down, its probably time for a new written step.

When you think you've covered it all in your instructions, go away and do something else for a while to clear your head (like purging a computer's cache). Later, pretend you don't know how to do the thing you've written about and that it's all completely new to you—and start at the top. Follow your directions, and only your directions. You'll soon know if you left something out. Are the steps clear and direct? Is there an easier way to say some part of it? Make all as focused and simple as you can. "KISS" or (Keep It Simple, Sweetie) is a good directional goal.

The truest test of whether or not you have written effectively

is to give the instructions to a willing volunteer. The less they know about the activity, the better you will be able to tell if you are communicating your goal, but try to find someone who is in your target audience. Instructions for children are going to be presented differently than for adults new to something, or for fellow professionals in your field of expertise.

Observe your volunteer as they proceed, and don't offer any help unasked. If there's a point where they don't "get" something, find a way to explain it and then you can fix that step later. Note any points of confusion on their part, or where you are just itching to say more and add or change as needed later, but allow your volunteer to finish what is there.

Find out how they feel about what they've accomplished. Was it satisfying? Fun? Do they end up wanting to hide their effort in a drawer, or are they raring to go again? What would they add or subtract to make it a better outcome? What would YOU do differently? Make your changes as needed, and try it again from the start. Find another volunteer and compare the outcomes; don't worry about whose finished art is "better"; instead ask whether some new level of skill or understanding was achieved. Keep at it until you all feel good about the experience. Then you can choose how you want to use your pictures and written instructions to format a finished product.

# Selling Your Instructions

When you have a certain way of doing things, an approach or technique that you have developed and refined, others will take note. If there is a particularly beautiful or useful result, then people are certain to want to know more about how to do it themselves. Artists of all kinds are often curious and quick to figure things out and apply them to their own work in their chosen media. Once a technique or result is widely seen, it will be replicated, changed, and shared in ways that the originator might never have foreseen!

As an originator or developer, you have the choice of never showing your work or of accepting that it will be learning spark to the imaginations of others when seen and admired. If you share freely, the flow of information and creativity will have many benefits. One big plus is that you have a say in how your technique or idea is presented.

Some of the other benefits can be material if you are willing to sell your instructions and be a part of the flow of people using and adapting your idea.

We've previously discussed doing this in person by way of classes, or with kits. Demonstrations are shorter than a class, and the participants watch instead of actively participating. Demos are a very useful way to advertise your instructional product; and if you videotape them, they can actually BE product. Video demos can be aired online as advertising, or as downloads requiring a small price to view. DVDs and CDs can be made using readily available equipment. It takes some skills to create quality product, and you can learn them as you go or hire those that have them. Many film students are actively seeking practice, particularly when paid for it.

Check with your local cable television stations and colleges for more information about where to post your ad or find interested participants.

There are replication services available locally or through the Internet that print and package DVDs and CDs, or it can be done as a home business. Computers and printers make it possible to create a package with a high quality professional appearance. Newer computers can even print graphics directly onto the discs as part of the information burning process.

Live demonstrations can be aired on television or done in public settings such as fairs or conventions. This can really draw attention to your products, whether they are finished items, kits, videos or printed work like books and brochures. If you have no personal desire to do demos, you can always hire someone else to do it for you when your product is ready for sale.

If you choose to write about your project or technique, you can sell your finished writing in several different ways. Magazines are quite often seeking new and interesting content. There are "Artist/Author Guidelines" for each magazine. Even they do not appear in the magazine itself, there is usually an address given where you can request them. This is true of book publishers as well as magazines. It is very useful to find out what each company particularly wants before you send in your "pitch" or proposal. Follow their guidelines as to the format you use in your presentation. Send good quality photographs instead of physical items, until such time as samples are requested. Then send items that are representative of your kit or items, but not irreplaceable pieces. Most publishers require you to send your proposals to ONLY one publisher at a time, so pick and choose carefully.

Then be patient and wait for response. It may take several weeks or more.

Starting with magazine articles is easier because they are both shorter and more frequently published than books. Find the magazines that feature the sort of project you wish to showcase---woodworking journals are a good choice for a quilting artist only if it's a wooden quilt pattern you wish to sell. See what is available at bookstores online and at local retailers; particularly at specialty shops in your media. Another valuable resource is The Writers' Market 2007, edited by Robert Lee Brewer. This book covers the basics of book and magazine proposals, successful query letters, and has addresses and contact information for all major and many minor publications.

When you create written works in the United States you have copyright protection whether it is registered work or not. Selling your written work can involve the complete and total rights transferred to another as a "work for hire" in return for a single payment. More common, and preferable for the artist in most cases, is a limited license for publication. In the case of magazine articles this usually refers to "first run (North American or International) publication rights." This means you will not sell it to any other publication before they have a chance to print it. This may take a while as most magazine space is scheduled far in advance of printing. Reprint rights may be specified in a contract but they normally revert to the author after publication. Always read anything you sign carefully and keep copies accessible for reference.

# Blogs–Building The Next Wave

What are they? "Blogs" are cropping up all over the Internet these days like fields of flowers, filled with all sorts of varied offerings. The term, a shortened form of "web log" refers to the personal sites that any person with a computer and an Internet account can easily build and maintain. Sites such as wordpress.com and blogger.com offer free accounts for unlimited blogging. This includes hosting, support and a wide variety of themed templates that make it easy for those with limited knowledge of web page fundamentals and more complex code. In order to have a Web Presence it used to require a great deal of involvement with several different computer programs and the ability to read and write (or at least alter) HTML codes, CGI scripts and all the other stuff that many of us don't even want to know about! These are still great skills to have and to increase but in the meantime, there are templates that allow anyone to follow clear instructions to insert their own pictures, text, color scheme and more. The user can make changes and add content at any time, and on whatever level of involvement they like; daily, weekly, monthly…or once in a while.

This means that if you've always wanted a web site of your own but lack the know-how or the FTP storage space, you can easily have one through the sites that offer these services. At minimum, a web based full-color advertisement for your art is up and running 24 hours a day. If you are willing to put some time and some work into it, you can create the equivalent of your own full color periodical online. As with web pages in general there are MANY that are not of interest, but there are also those that offer an incredible bounty of information and content. It is up to all of us to winnow through the multitude of offerings and pick out

those of value and interest to us. And then, when you find the best ones, share them with the people you know! That's how web sites and blogs and businesses become linked to and increasingly popular. The more people who know about them, the higher the likelihood of anyone visiting will be, and blogs have a built in audience of those who use the same service as well as those you tell about it or who hear from others!

If content catches enough people's fancy, blogs can be extremely popular and use up the sort of bandwidth that would cause many web sites to close off access to those with free accounts that have limited usage rates, or cause slowdowns or Not Available responses from smaller servers. Blog use can vary without causing the cost to go up, so sudden fame won't shut you down or cost an unprecedented amount.

How to catch that popular wave is the on-going question. It comes down once again to the quality of work being presented and to gaining the attention of those with an interest in it. Offering visual and written content of high quality can bring a lot of interest. Show works in progress, offer tutorials, link to other sites including your own online auctions or galleries in which your works appear—or just those that you like. Links are like street addresses; the URL (Universal Relay Language) address tells the computer where the page is to be found. It is legal and acceptable to simply link to the sites of others without gaining permission, just as you can verbally reference "Joe's Hardware Store on Main Street" without first calling them. But it is considered polite (and smart) to send the company a quick and friendly e-mail message and ask if they'd be willing to link back to YOUR site. And never include actual content from anyone's site without permission. Use only the URL or name of the site.

Other options that come along with blogs include automatic information feeds that allow readers to respond to your posts if you wish. Opening dialogue and allowing comments can be a source of increased reader interest. Be prepared to clean out unacceptable content unless you set up a filter or one is in place in the service you use. Check back frequently to see how things look on your page and to respond to comments if desired.

You can build on to your blog as desired, and create links to previous posts, create events calendars, even feature ads from programs like Google Adsense. Sell your items or build your audience, and then direct them to where your work will next be appearing. Using blog services makes the web much easier to access with your work, and that in turn makes potential customers able to access it too. The World Wide Web is a mighty tool, and it is easier than ever to be a part of it, though it still requires patience and persistence. If you have trouble, find a friend that has a blog and ask for help. If you can set up an e-mail account, you can learn to set up a blog. As your skills at presenting your work increase so will the number of "hits" or visitors that you get to your site.

# Books, Booklets And Brochures

"The Rise of the POD People!" sounds very much like the title of an old B Movie Science Fiction thriller. In the context of what's new with the Internet, the reality of today's POD (Print On Demand) publication services and Podcast shows can also seem like something we once heard the future might hold. Technology is catching up to many of the dreams that the artists and authors of the last 150 years have spun, and things have changed dramatically in many ways since the rise of the Machine Age. And yet, many things that the artisan does by hand have been done that way for many years, by many others before him or her. There is a long rich history of craftsmanship behind every wearable art form; weavers and dyers and tailors, milliners and cobblers, jewelers, embroiderers and lace makers. There is also a history of improving safety and working conditions, and a vastly widened variety of goods available to and from artisans of all kinds. Now the Internet's global availability of goods and services offers the kinds of opportunities that used to require a lifetime of travel and a fleet of merchant ships. All sorts of materials are now available without leaving the studio!

As well as bringing the world in to the artist in manageable doses, today's media can present the artist and their work back out to the world. In the 1900's advertising relied solely on print media in the form of books and periodicals. Professionals presented their work via lengthy and costly travel on lecture and performance tours. Then radio, film and television exposed the work of select talented individuals from around the world. A whole new world of opportunity arose for the presentation of art.

Today outlets that were formerly available only to a rarefied professional few are open to anyone willing to learn how to use the computer. Photographic, video, film and sound editing that used to require buildings full of sophisticated and very expensive equipment to do is now something that can be done on most modern home computers.

Not only can we view the output of other artists, we can now create and share our own. Professional quality print media is now within reach of all who are willing to do the work. "Print On Demand" publishers such as Lulu.com and LightningSource.com can take the digital files uploaded by artists and authors and use the same high quality, high volume machines that large publishing houses do to produce books, booklets, brochures or catalogues. There are no minimums and no set up fees, and buyers pay for only as many copies as they choose. There is a small base charge for each copy and then costs rise per page, black and white or full color. There are a variety of size formats from which to choose. There are choices to be made concerning the binding, like stapled or perfect bound or spiral bound. Both hardback and paperback options are available.

Bulk order discounts start at 26 copies, and authors set their own final prices for items they wish to sell. The company takes the orders, prints the copies and ships them, and gives the accumulated royalties to the author! Or, use them to print merchandise that is sold through your own outlets, or for use as your marketing tools. Calendars are another option for the entrepreneurial artist. Use your own photographs and text to create a marketable (and endlessly renewable) addition to your line, and then only order them printed as needed.

I have created beautiful full color calendars using the printers there as well as the book "Adapting Quilt Patterns To

Polymer Clay" coauthored with Judith Skinner. The colors are rich, the paper quality is great and the finished quality is very high. You might be surprised to know how many small publishing houses now make use of POD Publication services!

Other POD Publication sites include CafePress.com They are my favorite resource for screened or imprinted merchandise such as t-shirts and coffee mugs. Easy to use, and with no cost involved until merchandise is purchased and printed, CafePress is a great way to promote your business. Canvas tote bags can be printed on both sides with your uploaded 10"x10" high-resolution digital images, as can shirts and more than 50 other items. By using a graphics program, add your company name, a phone or URL, or other information. Create special promotional items or pieces that you sell featuring your designs.

By using their art in printed books, catalogs, clothing and collectables, artists can expand their inventory and promote their business. One copy of a high quality book of gorgeous photos of YOUR wonderful wearable art can go a very long way in showcasing your abilities, if shown to the right people.

Radio, television and film have their counterparts online as well, and now individuals at home or their studios can create and broadcast their own shows. For those who are willing to embrace the technology, the possibilities are wide open. We'll discuss some of them in the next column.

# Starring....YOU!

I was first gently drawn into the world of "podcasts" from Sister Diane (aka Diane Gilleland), organizer of the Portland Oregon chapter of The Church of Craft and hostess of CraftyPod, "the podcast and blog all about Making Stuff". As women have done for centuries, we talked and shared recipes but instead of dinner, we talked about preparing digital dishes and serving up information and images via the web. She asked if she could interview me for a pod cast about polymer clay, and I agree, requesting in return that she let me interview HER about pod casts...beginning with "What IS a podcast?" She told me:

"Well, I like the definition, "podcasts are like TIVO for radio... basically radio shows that you can find via the internet. And unlike traditional radio, you can listen to them whenever and wherever you like. And, podcasts are special because they aren't controlled by commercial media interests or advertisers. They are made largely by normal people like you and me. A pod cast is an MP3 file. This is basically an audio-file format that compresses audio way down until it's a manageable size.

I think that when an artist creates content like this, they're building a closer relationship with their audience. It's one thing just to look at someone's work. It's more intimate to read their blog. You feel like you know them a little better. Then, with an audio podcast, you're sharing your voice and another step closer in becoming a real, live person to your audience"

The listener can then use their computer or ipod to listen to these shows. There is a burgeoning world of them available

*The Business Of Professional Art*

on just about every subject you can name. You can also choose to subscribe, as you would to a magazine, but its free of charge! Subscribers are notified by e-mail whenever a new episode is released, saving you the bother of having to check on favorites. My interview (#46) with Diane is available at CraftyPod to anyone who chooses to click on the button and listen to 30 minutes about polymer clay. There are pod casts about knitting like Cast On, Pointy Sticks, and many others for your listening pleasure. To find them, Diane told me there are many directories that list podcasts including Podcast Pickle and Yahoo! Podcasts With these, you can browse for various categories of subject matter. Look for crafts, embroidery, quilts, or whatever your areas of interest.

Diane recommends that podcasters include information, pictures and even transcripts of the proceedings on an accompanying blog. I know from my own experience that I learn better when both vision and sound are involved, and its great to be able to work with my eyes and hands on something while my ears are busy listening.

Diane interviewed me via the telephone and recorded things at her end. We used Instant Messaging to allow me to interview her and create a transcript file at the same time. (To read the entire interview, visit my blog!) Both of us learned something about the other's medium, and it was effective learning because we both felt inspired to try it out as soon as possible!

Technology that is available to many people through home use, libraries, school and other venues can be used to learn more about anything, and it can seem terribly overwhelming at first. But when you persist and learn you become capable of learning even more, and of sharing what you learn with others, and of learning from them! Artists of

all kinds suddenly have venues available to them that used to be limited to a very select few. We can share information, techniques, sources, and inspirational energies. If you start by dipping into some of the content that already exists, you can find out how to present your own content to potential buyers. The development of web content of all sorts like e-mail, web sites, blogs, podcasts, even video content, can allow individuals to showcase and advertise their work in ways that used to cost hundreds of thousands of dollars and require several large teams of professionals to present. Those people still have work elsewhere, but now individual artists can create their own content affordably. For the entrepreneur with ambition, this is crucial.

If you or someone you hire has a digital camera and a computer with Internet access, you can create high quality catalogs, brochures, books and booklets, radio and video style advertising. All can now be created by anyone that is willing to put forth the effort, has access to a few machines and the free software available online, and who has something to showcase. Do YOU? Perhaps its time to show the world!

# Back To The Drawing Board

In previous chapters we've discussed many ways in which the home office containing a computer with Internet Access can be of tremendous value to the entrepreneur, especially when combined with peripherals like a printer, scanner, and digital camera. Today's tools allow an artist to invest less than $2000 and have at their fingertips all the tools needed to support their business with advertising, packaging, and content creation as well. But as wonderful as computers are, there is a time and place for the simple tools. There's nothing quite like a pencil and paper!

While the digital world has opened up tremendous opportunities for presentation, inspiration does not come in any software or hardware that computers can use. That's something that the human artist provides, and that elusive "something" needs nurturing, patience, and playtime. Our toys can provide inspiration, but a creative mind needs very little more than imagination and the freedom to use it!

Have you ever seen children having a marvelous time with a stick, or a string, or a cardboard box? Imagination turns them into ancient roman swords, exotic specimens, space ships…. anything at all. "Artists" are the people who remember that it is good to be able to see things differently sometimes, and who can share what they see with others. We still let our imaginations play. We experiment with designs and arranging things inside our heads, and then sometimes they end up becoming realized.

To some, the phrase going "back to the drawing board" might seem to indicate that there is some flaw or failure that needs fixed in an idea or concept. But it is truly more a starting

point, a place where ideas are allowed to begin without springing forth fully formed and polished. Both as a concept and as a literal tool, the drawing board is very important to any artist.

Studies have shown that the act of doodling, or drawing aimlessly with pencil or pen and paper, causes interesting changes in brain waves. It can reduce stress and allow for the kind of mental patterns that invite the creative state. The finished doodle art is never the point all by itself; instead look at it like the sort of warm-ups and stretching exercises that professional athletes do to keep their useful muscles limber and ready to perform.

As artists, not only do our hands need to be kept useful, so do our imaginations. There are no tools that can be bought which are as useful as our own hands and heads, but sometimes we forget to stretch and shake them out in a mental way as well as a physical one.

Try keeping a pad of paper and pencil handy---a convenient little notebook so that you can jot down ideas as they come to you, sketch an interesting curve that catches your eye, a juxtaposition of forms that has appeal. Some artists keep inspiration journals and cover the pages with pictures torn from magazines, dried leaves and flowers, even candy wrappers from other lands or other ephemera to be aides to memory. Jot down interesting book titles, phrases from conversations, snatches of song lyrics, or ANY sensory symbols that can later be used to summon up and encourage memory and creative connections.

Think if it as having different spicy ingredients available to flavor your mental menus. They don't need to be used Right This Minute or All At Once. But a little bit here or there can

be a wonderful thing. If you are working on a piece of art that has an oriental flair, looking at reminders of your trip to Tibet—or someone's trip—can be very illuminating.

If you aren't working on anything in particular, you can still take advantage of the creative energies that can be collected via your drawing board. Allow the opportunity to try out new design ideas even if they never do come down from the drawing board onto the worktable.

Play little games like taking a discarded magazine and finding shapes that you like or don't like in the pictures without regarding the image itself; look at the curve of a car fender, the angle of building, the shape of a shadow…later you can ask yourself what about the collection appeals to you or does not. Look at another magazine only for the colors in the pictures. Get out the scissors and gluestick and make a little pile of Do Likes and one of Don't Likes. When sticking the cutouts onto pages, pay attention to the ways the colors can be combined, how they draw the eye.

Artists all have their sources of visual and mental stimulation that they turn to again and again, whether it's the nearby landscape, classical art and music, books, magazines, movies or our own rich interior visions. By keeping a notebook, journal or paper folders full of clippings, we can take our inspirations to the drawing board and come up with something different each time, adding a bit of this or that and trying things out in each new attempt.

This kind of "play" is a very serious part of an artists work, and should not only be allowed, but encouraged! You never know if the curvy little lines with the thingy attached that you've doodled dozens of times while waiting "on hold" will become the start of a design for a silver brooch, a hooked rug, a quilt

top or the architectural plans for a museum building. Allow yourself the opportunity to play and find out. Some people have a harder time believing this is OK because they've been told its "wasting" time, if this is true for you then find a child or friendly grown-up and use them as your excuse to play; have fun together. Stringing simple beads with a child can be a wonderful reminder about color and shape to a jewelry artist. There's nothing wrong with going back around to the beginnings of things and back to the drawing board!

# Renewed And Refreshed

"Looking shopworn, tired, old, wrinkled, and faded..." is not a phrase I care to hear applied to my own appearance, or to my merchandise. And while a vacation or trip to a health spa might be the only way to improve my own looks, it is far easier and less costly to upgrade the presentation of one's artwork.

The start of a new year is a good time to take a long hard look at your "pushcart" and evaluate how you show your items for sale. Whether you have an actual cart or kiosk, a virtual storefront or you are a part of a larger sales venue is not the important point now. What matters more is how is that working for you? and does it need tidying up or outright change?.

In going over the merchandise that you have for sale, look at the work itself as well as at the packaging. Remove work that is no longer indicative of the quality you are currently achieving. Take the lesser quality items out of your stock, and retire them completely or give them away without your name brand on them. Selling them as seconds is an option, but one that can come back to haunt you later. I used to have a bargain box of beads and pins and things that were not of the highest quality. I stopped doing so when I saw some of these lesser pieces used in the work of others and then presented for sale in the same venues.

Now I give old beads and jewelry taken out of stock to schools, recreation centers or groups such as the Scouts for their own use and playtime enjoyment. These are not for resale, and they are not likely to show up at the next show that I do. They are then a charitable donation as opposed to a

marketed devaluation of current work--this is a much more positive way to move them along..

When you make this re-evaluation, keep in mind that this is not about whether you like the item or not. Use factual criteria instead of personal feelings, such as "does it have well-finished edges" and "are there visible flaws" rather than "I don't like orange any more". Glue smears will *always* be there on an offending piece, but someone else (the customer) might very well like orange even if you don't.

Repackaging merchandise can give it an entirely refreshed presentation that makes it suddenly visible again to prospective buyers. Don't be afraid to remove old headers or other packaging that has become bent or dirtied. It is not wasteful of time and material if it results in the item being salable again when it otherwise was being ignored.

Take a hard look before putting it in the new box, bag, or attaching the new header or tag and determine if this is a time to change that part as well. I have just re-designed my logo and replaced my business paper including the hang tags and headers on bagged merchandise, and it looks much improved. My new logo design no longer competes with the merchandise for viewing, and yet retains some familiarity, because it is the same company name. Name brand association is very important. I've kept the name and product information, removed distracting visual elements, and all it required was a ream of card stock. Along with the work to do the re-design, printing, cutting, folding and stapling and hole punching of course! That part is not the fun, exciting, creative aspect of making art. It is the plain old labor involved in marketing. And yet, that part is also vital to making sales.

My line's "new look" has already resulted in increased visibility and higher sales. It has been quite worth the price of some new plastic bags and some card stock, and the time making things look better was well spent. For many items that people regularly buy packaging costs exceed the cost of the goods, but it is the packaging that causes the consumer to notice (and choose) the item. That makes it a good investment.

This goal can also be achieved by rotating your stock regularly. If something does not sell after 3 months, consider replacing it in your display with a different piece. I have found that merely moving items to another part of the store makes them appear as "new things!" to the customers who shop there regularly. This is true on web page presentations as well. Moving sections of the page from top to bottom makes it seem as though it is all worth another viewing to many, and people often tell me they like the "new" parts.

Try new display units too. Earrings that have not sold in a glass counter might do better hanging from a standing display. Don't be afraid to try things in a different way or even in a different venue. It may be that the customers who want to purchase your items do not shop at the store where they are, so try a new venue once in a while. By trying alternative methods you can give new life to your merchandise without changing the pieces themselves. Subtle enhancements and changes can make things appear fresh again without the need for total overhauls to your line.

# Going...UP!

It's a good idea to clean out the lesser pieces from your line and repackaging with new headers, bags, boxes and tags can immediately improve the look of what you offer. However, here are also times when a complete re-evaluation of what you do is needed. Take time now to think ahead to the rest of the year, and give a good long look at the items you create. Do you still enjoy what you are doing? Do you like the look of the finished product and does it reflect the best quality work you can do? Does it show anything new that you've learned or skills that have improved in the last year? Do you wish to continue with these pieces, add others to the line, or create something entirely different? Do you have seasonal items? What items are selling the best, and do you want to continue with those or redirect sales towards some other part of your endeavors? The fact that an item sells well is not always enough to make an artist want to keep doing them over and over. Check your enthusiasm levels, and remember too that you can make the task of creating the "bread-and-butter" items that sell quickly more enjoyable if you reward yourself with time to experiment with new projects or designs as well.

It is necessary to build and keep momentum going up with a business. This requires a constant influx of items being created, and new exposures to potential customers. Many designers have seasonal showcases for their work, whether it is for Spring Fashions, Halloween Masks, Holiday Gowns, or Weddings, or other such timely frameworks. The time to prepare for these is at often at least a year in advance, and not the week before. January is a good time to start preparations for Christmas! It is also a good time for beginning the

foundations of the Spring line for the next year! Think way ahead in making plans not only for booking shows, but also for beginning the design lines that you will feature. It takes time and energy as well as perseverance.

Sometimes new items will compliment your existing line, and can be worked into your displays and sales very effectively. There are also those items that are so different as to make them better off when sold separately. Don't be afraid to branch off into other endeavors under another name or business identity. Its better to have two distinctly separate arenas beautifully done than a jumble in one. But do make sure that you have the energies and resources to go around before you split them! Don't be afraid to let go of a design or style that is not representative of your style or work anymore. But if you like the design and it is selling for you, there's no need to let it go just because it is no longer "new". Find a new way of approaching it—or just keep the classic elements that are doing well and be proud of them! While the designs themselves might not be changed, the line still needs to be refreshed with examples of your best work. You can also offer something "new and different" with details of materials or finishing.

Another thing that needs re-evaluating in an artist's line from time to time is the value itself. Pricing is something that many artists find very difficult to do effectively for two reasons. One is that they must keep an eye on what the market will bear. Sometimes it is just not possible to get the value of an item in a venue where nobody wants it. Then it is up to advertising to create that desire, or to display it elsewhere to those that appreciate its worth. Often this is a matter of timing as well as place.

The other very common reason is that artists will often not look at their own work with an eye towards its true value. Woman in particular are taught to diminish the worth of what they do in order to be "modest". When an item does not sell quickly, it is a common response to lower the prices, but this reinforces the idea of little worth in the eyes of the customer and the artist too. It is a daring move, but RAISING the prices on your items might just sell them faster! Do not disparage the value of your work by giving it a rock-bottom price. Take the quality of your work up, the quality of the presentation, and take the prices up too. If the items are not worth it they should be removed from your inventory. If they are worth it, you can let the world know it is available, and still at a fair price that reflects the value of your skills. As your skill and your reputation increase, so does the value of what you create, both now and later in any collectable re-sale market.

# In The Zone

There are days and weeks where finding the time to focus on your art is difficult or seems next to impossible. Be alert for the times that you can do small bits and pieces of your work, even if there are no uninterrupted blocks of free time that last for days! Most artists do not live in conditions that allow them to work uninterrupted all year long; daily life and the needs of others take their continuing place in the schedules too. When planning, make sure that you treat your business-time needs as part of the whole and give yourself the acknowledgement that what you do is A Real Job. Reserve time for your work needs every day or every week, as is required to meet the demands of filling orders or creating new work for your line. While you don't have to put work before family or health, be sure not to forget to put it on the list entirely or to always leave it for last. When you believe in the worth of your own work, you are better able to get the need for time to do the work across to others. Value your own time, and others will be more likely to value it also.

When you have that happy confluence of events that allows you time, energy, materials and a well-lit workspace all at the same time, enjoy it to the maximum! Focus on the work you enjoy when you can. This is great for your physical and mental well-being and also gives you the opportunity to practice and improve your art techniques, all at the same time. Studies and anecdotal evidence all show that the chemicals we have occurring in our bodies when we are creatively "in the zone" relieve stress, pain and depression levels.

This "zone" is a mental or metaphysical state where ideas and abilities seem to flow freely, almost without having to

think about it. It is something known to baseball players and Buddhists, writers, inventors and performers and artists of all genres. When it works, it really works! But how do you get "there" and what to do when you are NOT there?

Always keep in mind that there are ebbs and flows of creative energies. You will not be at your most creative peak every moment, and would burn out quickly if you were. So pay attention to your own creative rhythms and schedule time to do your artistic meditations (some call it "practice") when you are most likely to find the creative juices available to you. If you feel best in the mornings, take an hour then for your work exercises. If Midnight is your favorite thinking time, go for it then. And be patient with yourself when you are not in your top form while still doing things that help keep your abilities in good shape. Something that athletes and musicians know is that countless hours are spent in practice and privately conditioning your abilities for every moment that is spent in using them in performance before the public eye. This is true for artists too.

Always stay open to opportunities to exercise your creative muscles, even if they occur in unplanned or unexpected ways. While it is a wonderful feeling to have things going well and without friction in that "Zone", it is also very important for your development as an artist to meet and overcome artistic challenges. Be wary of staying within the box of what you already do well. Be brave, and try something new! Don't be afraid to occasionally color "outside the lines" as it were.

Allow yourself to challenge what you think you already know about a material's use, or use a technique that is not familiar. Make something beautiful in colors you don't usually use, or that you think you don't like. You might be surprised at how

your artistic perceptions can be gently coaxed to make more room for choices.

Try a Challenge with a friend and make a project using the other person's favorite colors and not your own. Or try something created "in the style of____". You can try a group Challenge with other artists and be creative in directions that you might not set out for on your own. The popular design show "Project Runway" has greatly encouraged this format of having several designers tackle a given objective. Seeing the differing results on a single project is very illuminating! Professionals often have to create work that fits a pre-existing demand. Even if you do not choose to design or work "to spec" for others as a career, meeting the challenge of making the customer (or instructor, or judge) appreciative of your work is good exercise.

# When The Muse Is Missing

What does an artist DO when they don't feel artistic? As anyone who has ever tried to "be creative" on demand knows, its not an easy thing. We are not performing monkeys who merely run through certain tricks and performances when the music starts up. And yet, as professionals who are earning both a reputation and an income, we can't afford to choose not to work just because we "don't feel like it". Even if the financial aspect is of no importance, a professional reputation has to do with many variables, including being able to provide high quality work within the stated time frame. Deadlines are not always moveable, particularly when you are working for others and not just within your own personal calendar.

Self-discipline is something that is needed in every professional field. Yet it is not often addressed in a straight forward manner by those preparing others for the working world. Perhaps this is one of the things that college educators feel that high schools should have instilled in students, and high school educators feel that parents should have already done. Leaving aside the question of who is really responsible for imparting the information about this skill to begin with, let us agree that it is in the best interests of a professional artist to behave not only as an artist, but also as a professional..

This means making agreements and meeting them. If it is not possible to do so, then a new agreement is needed. Communication is vital to behaving in a professional manner. Communicate with the client and also with yourself. Do not "forget" your scheduled work because you have other commitments or are tired or grumpy, or something more

fun comes along. The old adage "business before pleasure" is a professional adult's best method for success, because you never know what other things might come up. Putting work off until right before a deadline means that there is no margin for error, no room for unforeseen circumstance; no wiggle room.

When committing to a time frame, make sure to add in a little time for the unexpected. There will be times that family needs come up, or personal health issues make it difficult to perform your work. Even when your body is cooperative, sometimes the mental aspects of the creative flame are just not accessible. Do not make the mistake of thinking that this is a good reason to completely put off your professional responsibilities.

There are so many aspects involved in business that there is always something that can be done. Rather than choosing to not work at all when the muse is missing, do the parts that do not require your top creativity. Do the filing, cleaning, organizing, or preparatory work. Stretching canvases or mixing clay colors or sorting beads does not require creativity, just effort. So do the finishing details of previous work when you don't feel inspired to create new masterpieces. Sanding, drilling, ironing and folding, packaging or whatever the details involved in the final preparation and presentation of your art form, most of them require little in the way of creative inspiration. Many can be done when feeling under the weather. If you have the artistic equivalent of "writer's block" than do some editing of what's already been done. Or promote what you already have, find new outlets, and make sure that other details are dealt with. Mature people know that responsibilities do not go away by themselves, and make the efforts needed in order to deal with them in effective

ways. Generally this is much easier to do when they are not put off to the last minute before a deadline is reached. Sometimes the biggest difference between an amateur and a professional is the understanding that "Stuff Happens" and that adequate preparations must be made in advance. A professional works as much as they can even when they are not moved by inspiration, filled with wild happiness, or bursting with good health. Self-discipline comes in when understanding the difference between "can" and "want to". This does not mean that one should push so hard that health and well being suffer—that is not good use of your best tool, which is YOU! A good worker takes excellent care of their tools because it is much harder to do quality work with broken tools.

There are many ways to court the Muse into returning, and awakening awareness of the creative spirit again. It is also important to remember that in the cycle of Nature and all growing things, there are times when progress is slow or even dormant to the naked eye. And yet, as every farmer knows, a field that is allowed to stay fallow for a season may well yield more in the next growing cycle. However, seldom can they allow all the land to stay unused if they want to keep the farm from foreclosure. There's always something growing in rotation. Professional artists need to do the same.

It is important to allow for times when you are not creating at full blast. Plan some quiet time into your schedule, and use it when you need it. View it as part of the process of creativity, but not necessarily the only or first response to a lack of inspiration.

# Faith And Flexibility

We have a friend in the computer industry that tells us his best working advice for that world is to "Remain Flexible". This is so true for us all, particularly in times of economic disturbances. The rising prices of gasoline and diesel fuels make all forms of long distance travel more expensive, food and utilities costs are rising, and art supplies are also. This makes the cost of doing sales calls and traveling to shows higher, the cost of creating new work higher, and it is all happening at a time when many customers are cutting back on any non-essential spending.

Economic issues are fluid. It is the movement of money that makes a capitalist system work effectively and when that movement is hindered or stopped, all things are affected in outward ripples. It is important to remember that there is no less money in the world than there used to be, even when the flow is visibly slower or not filling up the same reservoirs of resource that it used to do. There are cycles to this ebb and flow just as there are with water with rainy days and drought both being natural parts of that cycle. Some years are better for selling your art than others, and it requires faith in what you are doing to endure through the times that are tight. Having a financial nest-egg to help with the costs is wonderful at any time and particularly so in harder times. However, many artists have their fortunes tied up in their tools and materials, and being under-funded is a way of life. This makes those who are used to a very lean budget better prepared to survive in many ways, partly because they are already conditioned to the nature of the struggle and have the knowledge that it IS possible to survive and prosper.

Faith—belief in something larger than your self—is a known factor in helping people to survive adversity. It is something that we all need, and that is stronger when shared. This is true no matter what form that faith takes; religious or secular.

In attending Tougaloo College Summer Art Colony in Jackson MS this summer, I was immersed in the uplifting and heartening energies that we all shared without regard to the limits of any one media, or any one social, economic, political or educational background. As an instructor there, I was fortunate to be able to take in all the enthusiasms and creative talents of the participants and give back in a flow that enriched us all. The emphasis was on what we do and where we are going, not where we are from or the monetary costs or possible profit of the journey.

My annual local guild retreat functions in the same way. We are always revitalized and our creative fires stirred with fresh ideas and concepts, with new information and a re-cognition of the personal strengths that art as a way of life bring to us...even when the riches are not always the kind that can be taken to the bank on Monday.

Make an effort this year to keep your own faith strong by sharing it freely. Keep up your part of the economic flow by purchasing the things you need from local merchants and artisans, and be flexible in your output as well. Sell off unused tools or supplies at a price that allows some income to flow your way at the same time that it enables another artist to continue in their growth. Have an artisan's party where everyone brings supplies they are willing to let go of and want to add to the flow. These can be sold, swapped, or even donated to a local school or nonprofit organization that encourages creativity in children, handicapped, or elderly

persons. Think bigger and work with that same non-profit group to hold a sale of your art, in which 25-50% of the proceeds go to the charity. This doesn't have to be held in a large commercial venue—it could be done in the home of a board member or other concerned patron, or in the group headquarters.

Be flexible and willing to accept changes that are needed for survival. If you create large expensive pieces that are not selling quickly, try some smaller work as well. And sell the larger pieces in a smaller format. The $2000 wearable wonder may take a while to find its owner but it is possible to sell quite a few of the $2.00 cards of the image.

You don't have to give up your art in order to survive economic difficulties, but some plans may have to be scaled back, postponed, or done differently than you had envisioned at first. This is not "failure" in any way. This is the practical reality that is part of business every day, no matter how things may look on paper at any time. Change and adaptability are part of growth. Maintain your belief in what you do artistically and be willing to go beyond what you are comfortable with having done previously if needed.

Trade for goods and services. See if your chiropractor or your hairdresser or other service provider will barter. Spread the joy and hope that are contained in creative processes and know that we will again see more prosperous days. Even the times while we wait for income opportunities will be more beautiful and enriched because that is the gift of art. We can help make any trouble more endurable, and keep ourselves and others empowered and ready to continue and to thrive.

# An Ethical Business

We talk about a great many things at my house. With artists, musicians, writers, and college students of many kinds adding to the conversational mix, there is always a great deal to think about and ponder, and "ethics" are not just something studied in class or mentioned in a book. A system of how you choose to do things and what you choose to believe in as "good" and "bad" behavior effects everything you perceive and do, in life, in love, in art and in business. When these things are combined together into the lifestyle of the professional artist, it is all the more imperative to behave in ways that truly promote your beliefs, whatever they may be. When these ideals and actions are consistently valued and enacted, great things are possible. However, if your actions do not fit within your beliefs then energy is lost, clarity is lost, and good work is not easily accessed.

From one of the most honorable businesmen I know, who is a professional performing and recording artist and an instructor to other musicians, we recently received this quote about ethics in business:

*The Four Pillars of The Ethical Company:*
Honesty
Responsibility
Equity
Goodwill

transparency + straightforwardness = honesty
accountability + owning-up = responsibility
distributive justice + fairness = equity
common decency = goodwill

These things pertain to all personal and commercial business equally—to the arts, the sciences, to personal services and to merchandising of every kind. They are the kind of sub structural foundation that is vital to any potential personal success. You can certainly gather money without having them....but you will not prosper as an artist and a person in the same way that you will with ethics in place. It is important to remember that as an artist, you are building yourself as a creative entity as well as your status as a merchant and your line of goods. Quality takes effort to achieve on an ongoing basis!

Honesty requires that you back up your commitments with actions and limit the number of empty promises you make as they will only limit your true productivity. Mean what you say and say what you mean and you will find that business matters are simplified. Keep track of appointments and learn to be on time, even if it means setting the clocks ahead by five minutes. Be honest with yourself about what is needed for you to do good work, and provide it.

Get enough sleep, eat nutritious food and provide yourself with artistic and musical stimuli that you enjoy, or quiet times to think—you know you need these things to perform well, so ensure that you get them. This is one way of behaving in a responsible way. Take care of your tools; put them away so you can find them again, keep them available and ready to be used effectively. Replace what's broken or used up and be ready when inspiration is ready for you.

Give credit to those who influence your work and honor your own part in a long chain of creativity whose cord is made up of many twined parts. No one creates art in a vacuum; we are all influenced by what has gone before us. If you make

a mistake, admit it and learn from it. Apologize to those involved when you do you any harm. It is not terrible to make mistakes but it is not right to leave them that way. Always learn from what happens. If you break something, or use up supplies, replace them.

Treat others the way you want to be treated. Equitable justice means that if you want others to pay their bills, you too should provide what you owe. Participate fairly in the system in which you operate. That means pay your dues; keep your license current, and honor your debts.

Pay your taxes and participate fairly in business--cheating costs more than it is worth, even if you get away with it; perhaps especially then. This is true in matters of money, love and everything else. If your business employs others, pay them what they are due, when it is due. Honor your agreements completely and openly.

Don't ask others to do things that you are not willing to do yourself. You can hire others to do things that you may not be capable of doing yourself—but ethical management means not exposing others to risks you would not willingly endure. If there are safety issues in your workplace, always deal with them in a responsible way. Sweep up the broken glass bits, use a mask when spraying, wear eye protection when the particles may be flying—these things are important to long term business prosperity though they may not seem like it in the moment.

It can seem that these things are so simple that they would not even need to be mentioned. And yet, ethics are the very basis and foundation of actions that will have effects on many levels, from the esoteric to the intensely practical.

When these standards are in place and held true even when we are unobserved, then we need not spend so much time in deciding what is the right thing to do. We know. Our responses to what we know are what form our abilities as artists.

*As professional artists, we are required to be aware and responsive.*

*As ethical beings we can grow and refine our abilities in ways that will improve awareness and feed artistic growth.*

Do good work and have fun with it. That feeds your artist self in many ways. It is a self-fulfilling cycle, and we can all tap into the energies it promotes, if we are willing to behave in ethical ways while knowing that this requires effort and self-discipline. We already know it is all very much worth the time and attention it takes—or we wouldn't be artists in the first place!

LaVergne, TN USA
14 October 2010
200826LV00004B/5/P

9 780980 031218